FEATHERS

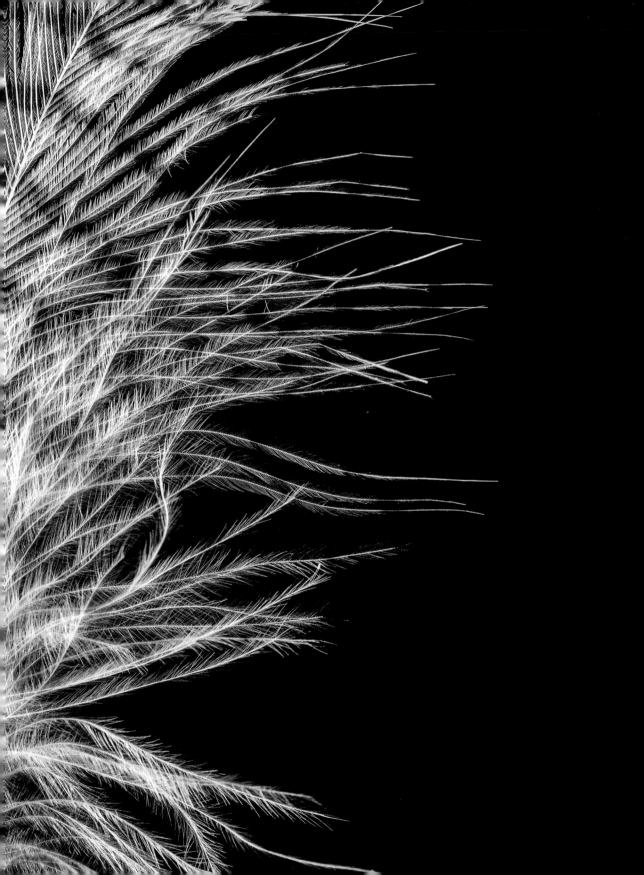

FEATHERS

—

DISPLAYS OF BRILLIANT PLUMAGE

ROBERT CLARK
PREFACE BY CARL ZIMMER

CHRONICLE BOOKS
SAN FRANCISCO

Library of Congress Cataloging-in-Publication Data

Clark, Robert, 1961- author photographer.
Feathers / Robert Clark.
pages cm
ISBN 978-1-4521-3989-0
1. Feathers—Morphology. 2. Feathers—Pictorial works.
3. Photography of birds. I. Title.

QL697.4.C54 2016
598.1470222—dc23

2015026260

Design by Sara Schneider

Manufactured in China

10 9 8 7 6 5 4 3 2

Chronicle Books LLC
680 Second Street
San Francisco, CA 94107

www.chroniclebooks.com

Page 2:

SPOTTED EAGLE-OWL

This detailed shot of the Spotted Eagle-owl's downy feathers shows that the barbs of
the feather don't connect with one another, giving the feather a hairlike appearance
that allows more warm air to be trapped in the down.

ACKNOWLEDGMENTS

—

The creation of *Feathers* was an education for me. Before I began this project, I had no idea of the complexity, the origins, and the beauty that make up the history of feathers.

I could never begin a project like this without the help of *National Geographic*, which gave me the initial assignment that inspired this book. The research, planning, and critical eye of their deputy director of photography and a wonderful photo editor, Kurt Mutchler, provided me with constant encouragement and inspired me to learn more about the history of feathers.

During my photography and research I was able to work with and get advice from great minds like Xu Xing of the Chinese Academy of Science, and Rick Prum, the William Robertson Coe Professor of Ornithology and Head Curator of Vertebrate Zoology at Yale University, who helped me understand the broad strokes of the evolutionary story of feathers. Jakob Vinther, PhD, at Yale and Ryan Carney, PhD, at Brown were invaluable to my understanding of fossil evidence.

Numerous museums played a critical role in the making of this book: the Institute of Zoology and Zoological Museum at the University of Hamburg, the Institute of Vertebrate Paleontology and Paleoanthropology at the Chinese Academy of Sciences in Beijing, the Museum of Natural History at Humboldt University of Berlin, and the Shandong Tianyu Museum of Nature in Lioaning, China. The feather collections of the Prum Laboratory at Yale, the Peabody Museum, and those of Peter Mullen, PhD, and Gabriel Hartman added dimension and beauty to these pages.

When it came to the production and preparation of the book, I couldn't have done this without Parker Frierbach's hard work, research, assistance, and passion for the project. I was lucky to have someone so interested in the subject and dedicated to the book's beautiful completion.

The editors at Chronicle Books, Bridget Watson Payne and Rachel Hiles, guided this project from an idea to the pages with grace and understanding. Thank you.

The people in my life—my wife, Lai Ling, and daughter, Lola—are the two wings of my life that give flight to any and all of my best ideas.

PREFACE

—

BY CARL ZIMMER

I live near New Haven, a small city on the coast of Connecticut. It is hardly a wildlife refuge, and yet there's always some astonishing biology on display, if you just think to look for it. The Pigeons strutting across the town green show off their iridescent pink feathers with each bob of their heads. Goldfinches shoot among New Haven's bird-feeders like lemons fired from catapults. Crows congregate in parking lots, their feathers blacker than the asphalt underfoot. In the streams and marshes of New Haven's parks, the Egrets stalking fish look like bleached feathered statues. Seagulls drift overhead, carried by the currents from Long Island Sound, their feathers the color of fireplace cinders. Each bird has over a thousand feathers, and in a single day in New Haven, you could easily see a million of them. And yet, unless you push your brain in a birdish direction, you might not give those feathers a single thought.

That's a shame, because there is no better way in our ordinary lives to confront evolution's riot of invention and beauty. The earliest evolutionary hints of feathers can be found in the fossils of dinosaurs. Once people dreamed of *Tyrannosaurus rex* covered in scales. Today, science has covered the giant reptile in an improbable fuzz. As the dinosaur evolutionary tree sprouted new branches, some species gained more elaborate plumage. Simple bristles began to split into downy feathers. Others took on the shapes of pennants. Over millions of years, more kinds of feathers evolved, and small dinosaurs probably began to use them to help them move around. According to one theory, dinosaurs initially flapped their arms up and down to help them climb up steep inclines or down steep slopes. Feathery dinosaurs may have also used their plumage as parachutes, extending their leaps from branch to branch, or tree to ground. One lineage of these dinosaurs evolved

skeletons and muscles that could harness the full power of feathers, flapping their arms up and down to generate fully powered flight.

Scientists can gain clues to the evolution of feathers not only by looking at fossils, but also by studying how they develop in bird embryos. There are outgrowths of cell clumps in the skin called placodes. It only takes slight tweaks in the genes that are active in placodes to cause them to produce the shaft of a feather instead of, say, a reptile scale. Feathers are thus an evolutionary rejiggering, rather than something that sprang out of the void. Birds also evolved new variations on the proteins found in other animals, producing special forms of keratin and other proteins that give their feathers different colors and physical properties, each suited to a different function.

And how many other functions there are! A bird can use some of its feathers to fly, others to stay warm, and still others to attract a mate. And among the ten thousand species of living birds, evolution has produced a staggering variety of feathers for each of those functions. Penguins, for example, produce tiny, nub-like feathers on their wings that keep them warm in the Antarctic Ocean while also allowing them to, in effect, fly through water. Owls, on the other hand, grow feathers on their wings that muffle the sound of their flight as they swoop in on their victims. The tail feathers of a Lyrebird grow to elegant twisted heights to attract a mate. The Club-winged Manakin has feathers that produce violin-like notes when flapped. The female Club-winged Manakin doesn't choose a mate based on how his feathers look so much as how they sound.

Even a city like New Haven can offer some of that diversity, if only we open our eyes and minds to it. But the world of feathers stretches far beyond Pigeons and Goldfinches. In this gorgeous book, photographer Robert Clark shows us feathers in a scope that few of us ever imagined. In the process, he demonstrates how inventive evolution can be.

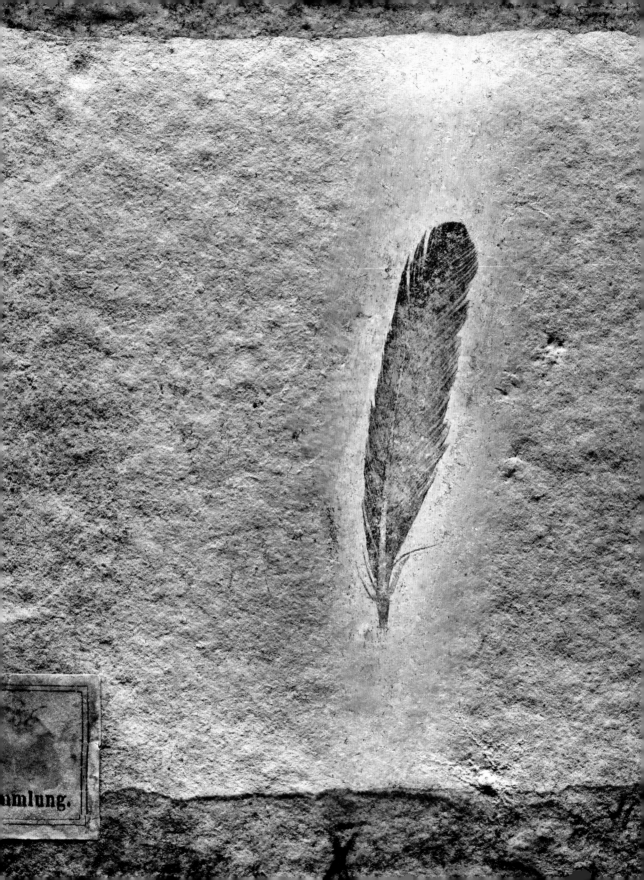

mlung.

INTRODUCTION

—

My fascination with birds stretches back into my youth, when I would gather feathers of Meadowlarks, Crows, and Quails in Western Kansas. As a child, I started observing the Doves and Red-tailed Hawks endemic to the area. Every year I'd watch the Sandhill Cranes flying along their migratory path at the Cheyenne Bottoms Wildlife Area, close to my home.

My interest in birds grew while I was working on a story about Charles Darwin for *National Geographic* in 2004. As I examined Darwin's life, it became clear to me that his interest in and understanding of evolutionary processes grew encyclopedic during his five-year voyage aboard the HMS *Beagle*. During that time, while studying the wildly varying sizes of Finches' beaks in the Galápagos Islands, Darwin conceived the notion of island bioevolution: the isolation of a species plus time and adaptation to local conditions leads to the origin of new species.

After Darwin returned home to England, he began breeding Pigeons. In his breeding he was trying to accelerate evolution, looking to the birds' skeletons to see if his selection had led to any morphological changes. The varieties of Pigeons he raised were astounding.

As I studied Darwin, the evolution of the feather began to occupy my mind, and throughout the next decade I continued to photograph birds as I did more work for *National Geographic*. Eventually this led to the opportunity to work on an article published in February, 2011, "Feather Evolution: The Long, Curious, and Extravagant History of Feathers." That story led me into the 200-million-year-old history of one of the most beautiful yet ubiquitous objects of nature. As I became astounded by the extreme variation, formation, and coloration

of the feathers that covered each bird, the story took me to Liaoning Province in China to shoot a collection of Confuciusornis bird fossils from the Early Cretaceous Yixian and Jiufotang Formations, dating back to before the death of the dinosaurs, some 125 million years ago.

The ways in which feathers have evolved and manifested themselves over time is riveting to me; over millions of years the scales of a dinosaur deviated and began to grow upward in spines that covered the body of birds. Through many generations, these spines spread, evolving specific purposes for the regions on the body on which they grew; eventually these spinal structures were imbued with extravagant colors and features. Feathers evolved for all kinds of purposes: flight, insulation, sexual attraction, camouflage.

I have pored over thousands of feathers and photographed hundreds. From fossilized feathers dating back millions of years to the spectacular feathers of today's Bird-of-paradise, *Feathers* chronicles the amazing evolution of plumage. As the saying goes in architecture, "form follows function," but when it comes to feathers I would say if form follows function, then beauty follows form.

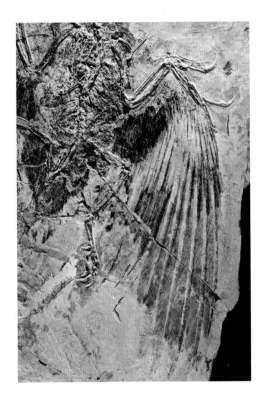

PAGE 8:

ARCHAEOPTERYX

GERMANY
ARCHAEOPTERYX LITHOGRAPHICA

A single distal secondary feather from a deposit of fossils discovered in Solnhofen Community Quarry in Germany, in 1861—a year after Charles Darwin and Alfred Russel Wallace announced their theory of evolution. The fossil, which has reptilian and avian features, stirred up further turmoil in the already controversial discussion of evolution. For a long time this feather from the late Jurassic period—more than 150 million years ago—was the oldest known example of a feather in the fossil record.

ABOVE:

CONFUCIUSORNIS

LIAONING PROVINCE, CHINA
CONFUCIUSORNIS

This *Aves* variation, discovered in the Liaoning province of China, shows a member of *Confuciusornithiformes*, a group of bird predecessors all identified by talons evident on their forelimbs. Named after the Chinese philosopher Confucius, these animals are the oldest known birds to have beaks.

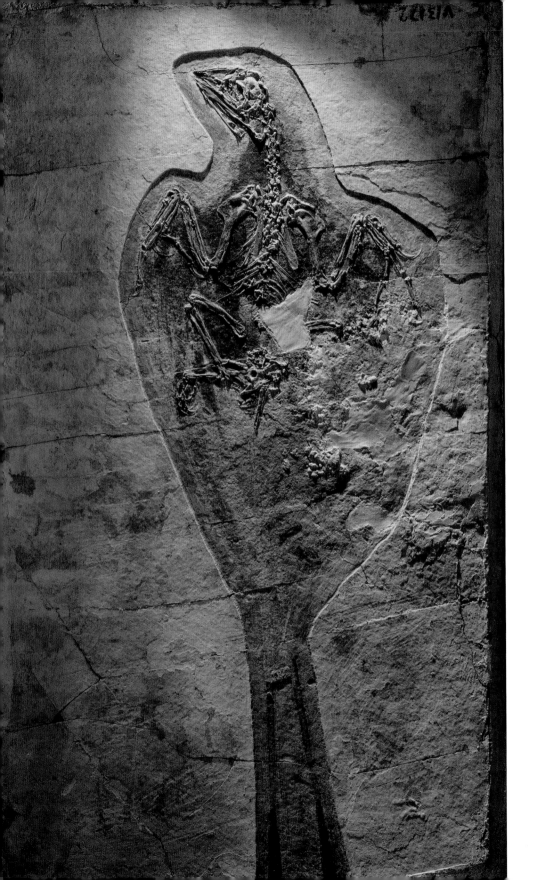

OPPOSITE PAGE:

CONFUCIUSORNIS

PINGYI, SHANDONG PROVINCE
CONFUCIUSORNIS

Another shot of the *Confuciusornis* species, detailing how reptilian their structure remained even as they had developed much longer and complex feathers.

SUPERB LYREBIRD

—

EASTERN AUSTRALIA

MENURA NOVAEHOLLANDIAE

Found in the forests of Australia, this species is known for the male's ability to mimic sounds from their environment, ranging from complex birdsong to the sound of a chainsaw being used in the woods. The male Lyrebird's feathers, which resemble a lyre when fanned out, are crucial to their courtship.

The mating rituals of a Lyrebird are just as complex as their birdsong. The male birds build a mound of topsoil on which they sing and fan out their feathers in a grand dance to attract a mate.

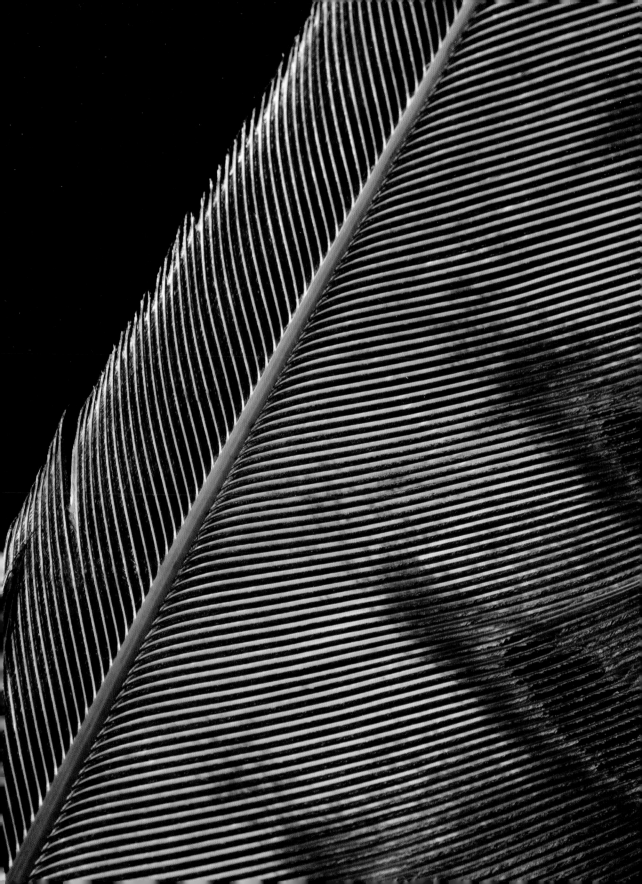

SUPERB LYREBIRD

—

EASTERN AUSTRALIA

MENURA NOVAEHOLLANDIAE

Another detail of the Lyrebird's ornamental tail feathers. The tail feather is purely ornamental and not a flight feather.

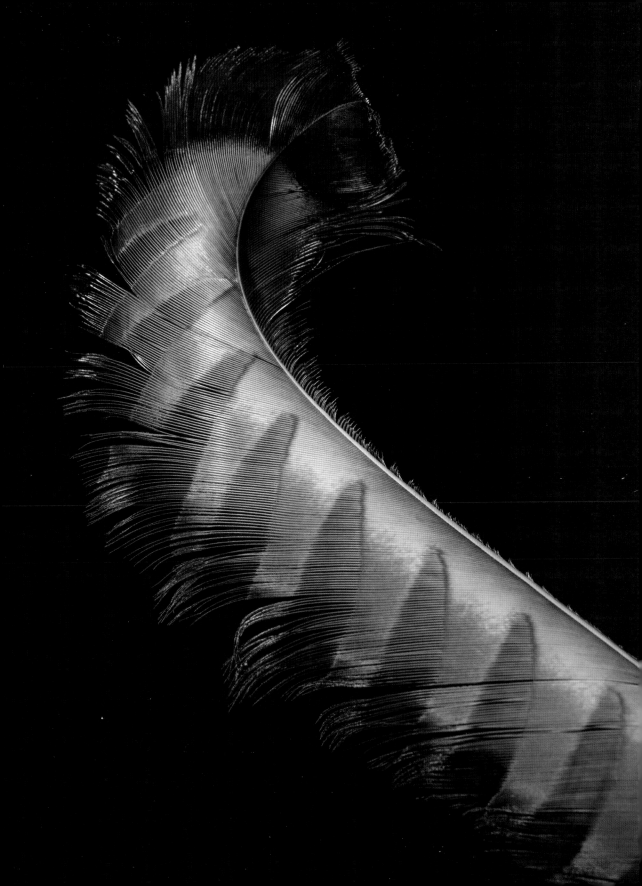

SCARLET MACAW

—

SOUTH AMERICA

ARA MACAO

The coloration of this Macaw allows it to live in and blend into diverse habitats. While the bird has been subject to habitat loss, so far the species has proved to be widespread and adaptable enough to avoid major threats to population levels.

The plumage of this Parrot ranges from rich reds to deep blues. Here is shown a secondary wing covert feather. Covert feathers cover other feathers, and allow air to flow over the bird's wings and tail. Scarlet Macaw's strong wide wings allow them to reach speeds of up to 35 miles per hour.

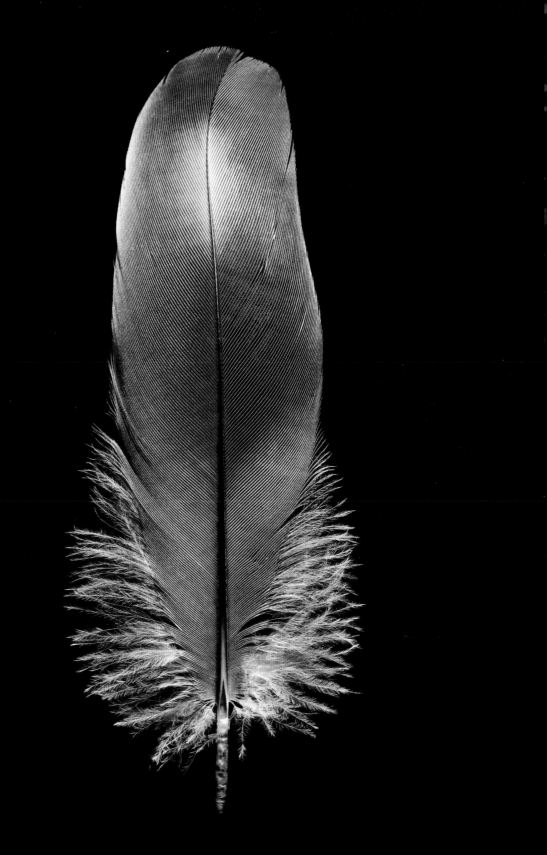

BLUE-AND-YELLOW MACAW

—

SOUTH AMERICA

ARA ARARAUNA

One of the more recognizable variants of the Macaw, this bird is popular as a pet throughout the world thanks to their ability to talk and bond with humans. Wild populations are found throughout South America, ranging as far north as Florida. The Blue-and-yellow Macaw is not a light bird, so their primary feathers have to be long and strong in order for the bird to be capable of sustained flight. The Macaw's flight feathers are shaped with a shorter leading edge and longer trailing edge. The leading edge is curved and forces air over the upper surface of the wing, creating lift during flight.

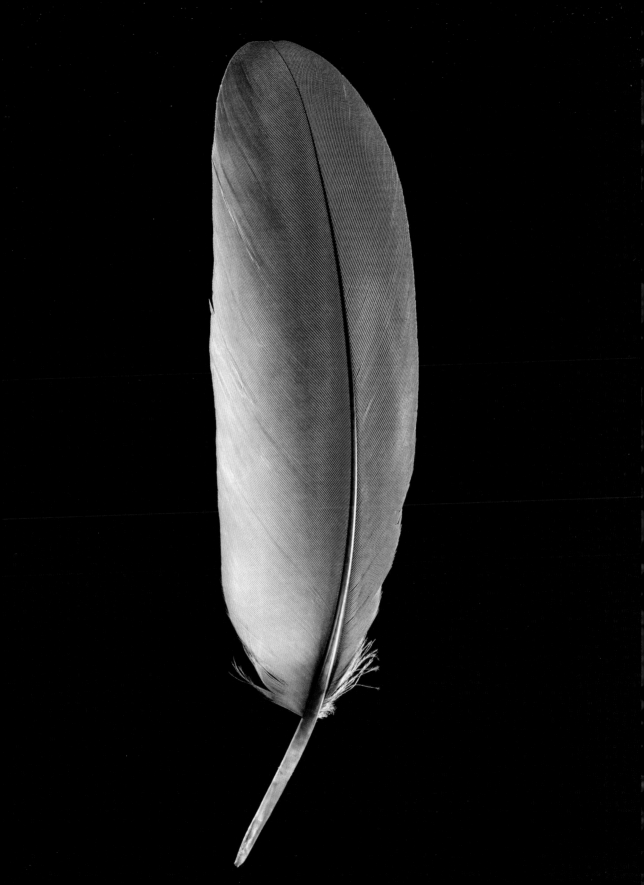

BLUE-AND-YELLOW
MACAW

[detail]

—

A detail of the resilient feather shaft of the Macaw's primary feathers.

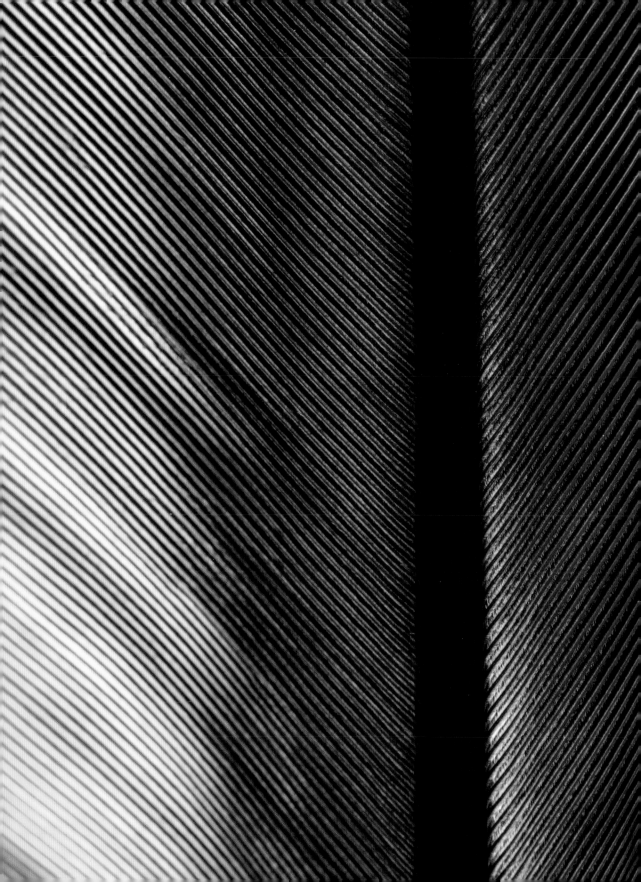

following spread:

NAUMANN'S THRUSH

—

EASTERN ASIA TO EAST-CENTRAL SIBERIA
TURDUS NAUMANNI

This expanded view of the right body feathers of a member of the Thrush family shows the many different feather types in the wing, ranging from the downy flexible semiplume feathers to the stiff flight feathers.

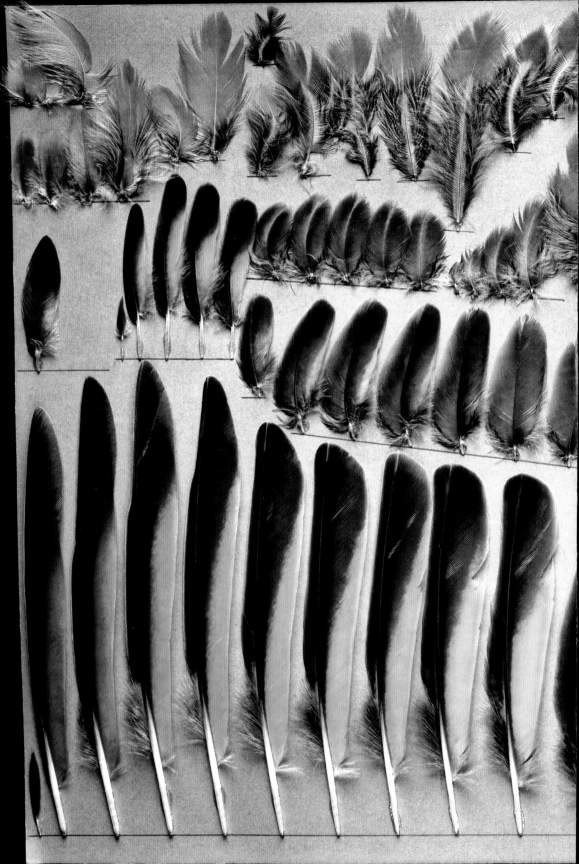

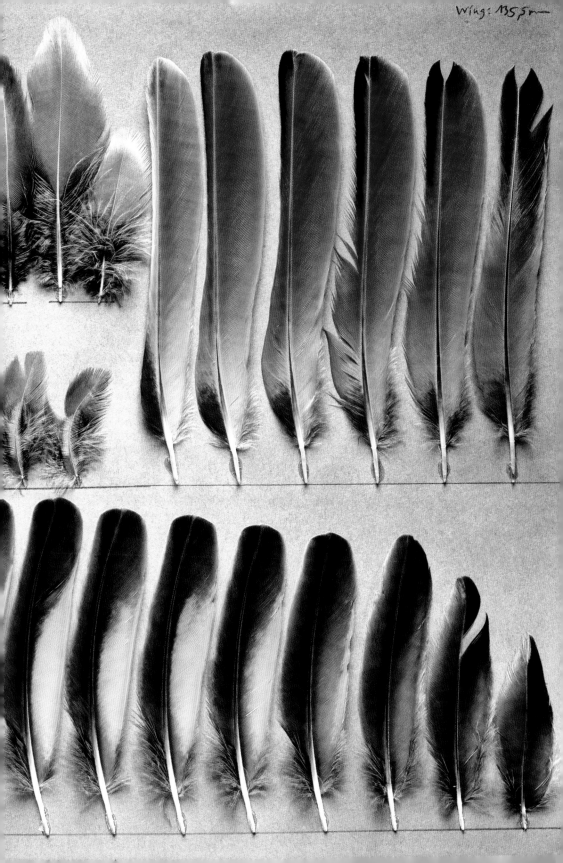

Wing: 135.5m—

following spread:

WILSON'S BIRD-OF-PARADISE
—

WESTERN PAPUA NEW GUINEA
CICINNURUS RESPUBLICA

This image shows a single tightly folded tail feather of Wilson's Bird-of-paradise. The most curious feature of this species is the elaborate display the male birds employ to attract a mate. During mating season, the male birds first make a clearing on the forest floor, removing all twigs and detritus. Once a female suitor arrives, the male performs a dazzling dance.

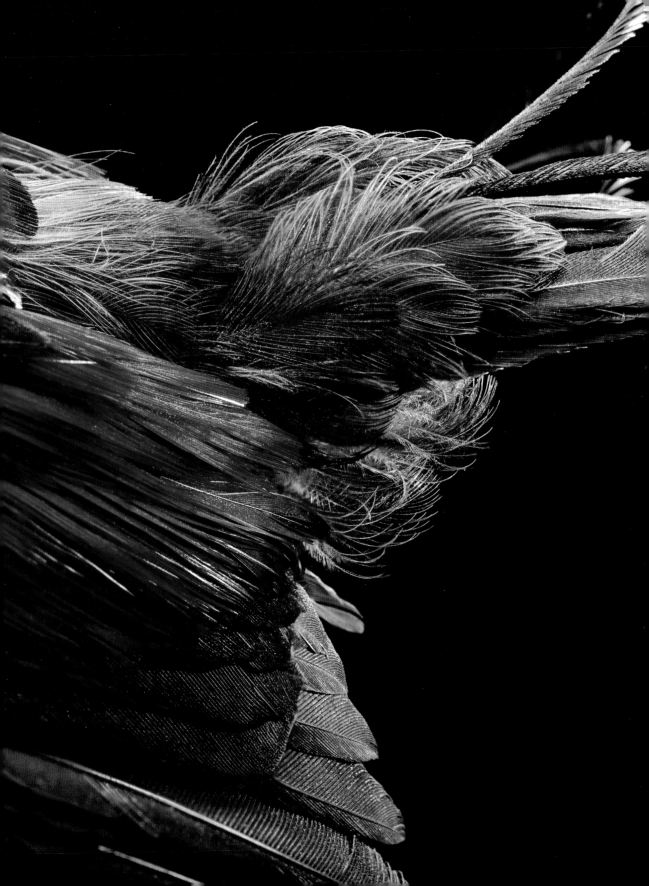

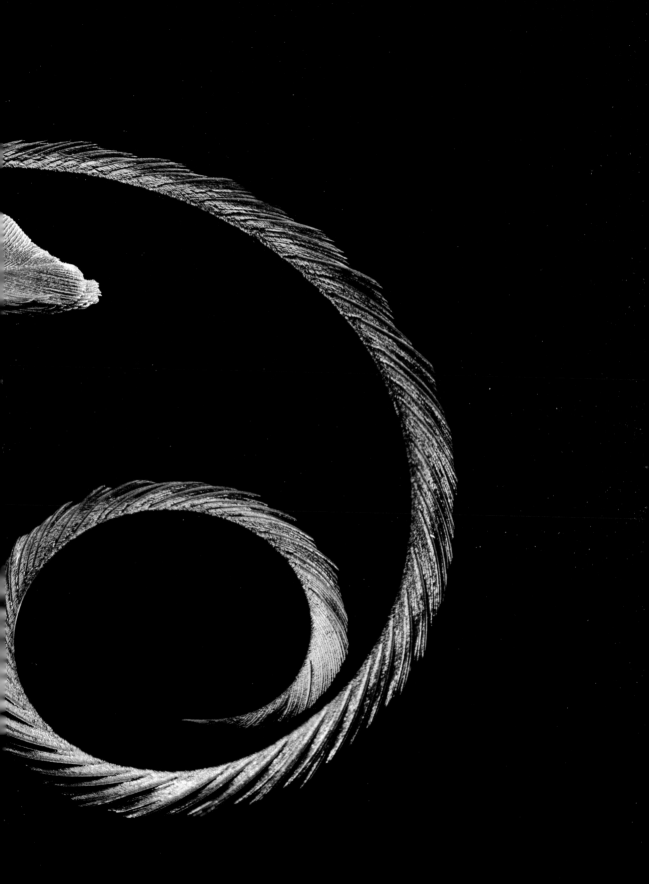

RED
BIRD-OF-PARADISE

—

PAPUA NEW GUINEA

PARADISAEA RUBRA

The Red Bird-of-paradise is one of the seven hundred vibrant bird species found on Papua New Guinea. Because New Guinea is an island with few predatory species, local bird species have flourished in the face of little competition.

The Red Bird-of-paradise is an example of the extreme sexual dimorphism apparent in the Paradisaeidae family. Like Wilson's Bird-of-paradise, the male Red Bird-of-paradise displays its extravagant plumage during mating season. Prancing in front of potential mates, the males spread vibrant red tail feathers out in a grand fan and two corkscrewing quills emerge from the bird's rump, adding to the mating spectacle.

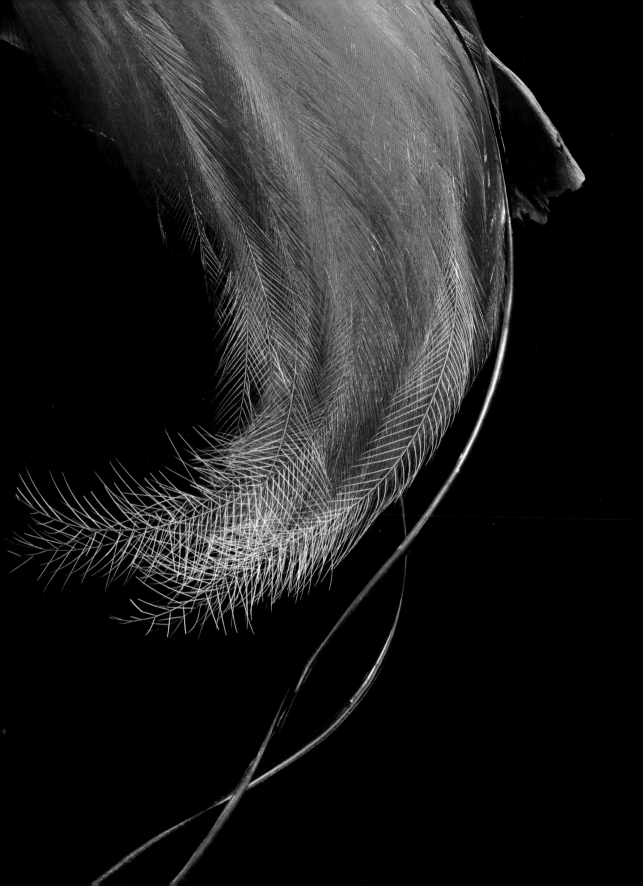

KING
BIRD-OF-PARADISE

—

PAPUA NEW GUINEA

CICINNURUS REGIUS

The King Bird-of-paradise is a bright red bird with oddly shaped wings. The pair of tail wires shown in this photograph serves non-mechanical purposes; like other Birds-of-paradise, the King uses its bizarre feathers in a complex mating ritual.

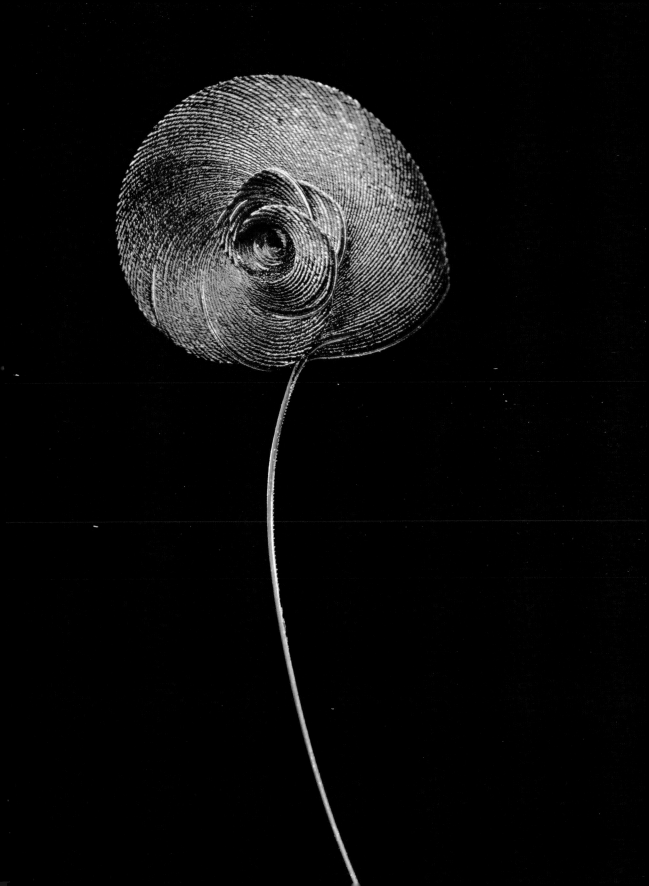

following spread:

SOUTHERN GIANT PETREL

—

ANTARCTIC REGION THROUGHOUT THE SOUTH GEORGIA ISLANDS
MACRONECTES GIGANTEUS

Arctic birds are a hardy breed. They have to survive in a hostile and difficult environment. To survive, the birds developed physiological and biological adaptations, including nasal passageways that filter out the salt from the air and wax ester–filled glands that the birds use to spit on attackers. Due to their diet of carrion, offal, discarded fish, and waste, Southern Giant Petrels are often known as "stinkpots."

This image of the bird's wing shows a dense overlay of feathers that gather together to form a high-aspect-ratio wing type, designed to fly with minimal effort in all conditions, allowing the birds to glide for much of their flight as they soar throughout their enormous roaming area.

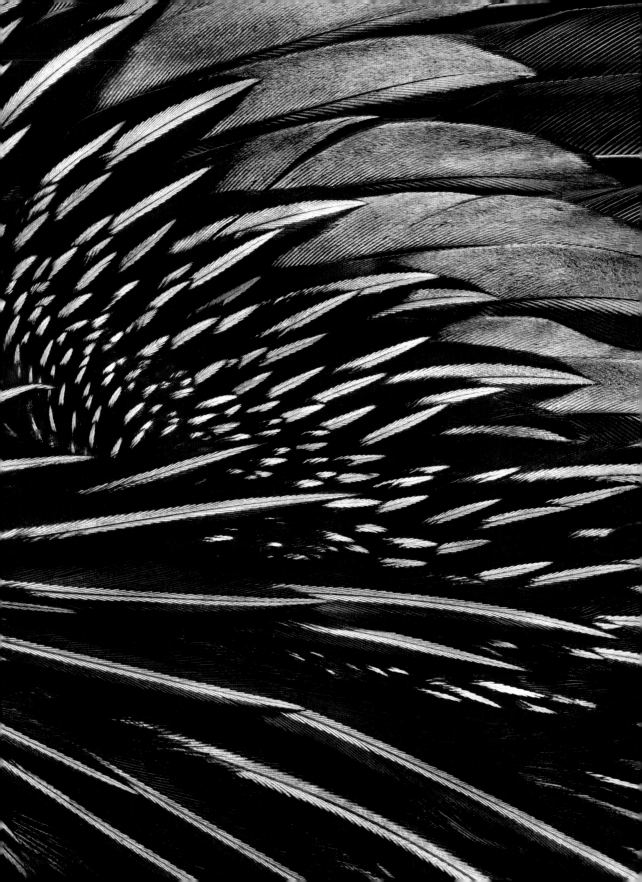

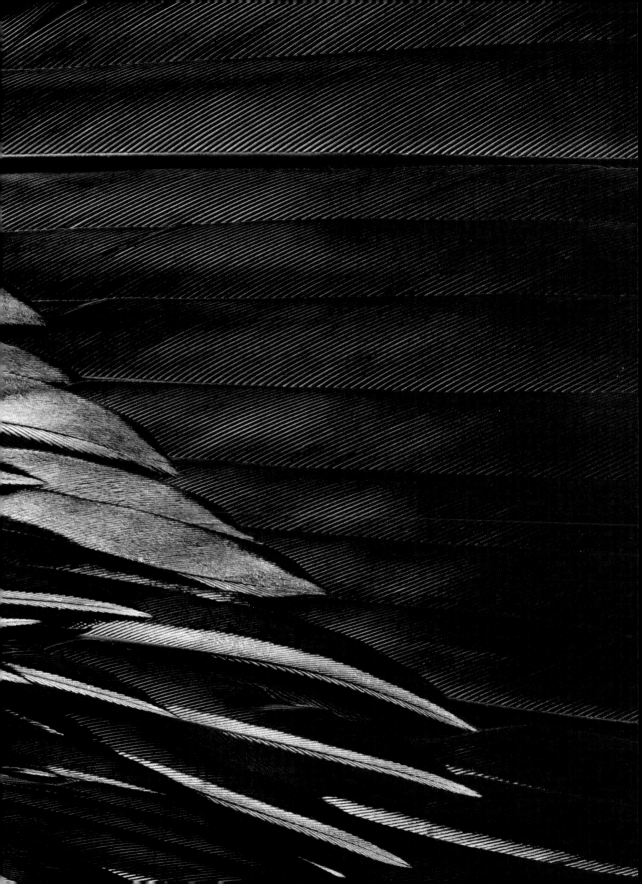

following spread:

GREAT ARGUS
—

SOUTHEAST ASIA, MALAYSIA
ARGUSIANUS ARGUS

At first glance, the Great Argus may appear to be a quiet-foraging, Pheasant-like bird from the Phasianidae family—until mating season. The wing feathers are the crown jewel of the Argus's plumage. In an elaborate mating dance, the male Argus fans its wings toward the female, creating a conical display of spots. Large eye-like spots known as *ocelli* cover the primary and secondary wing feather groups. Some evolutionary biologists believe that the ocelli are meant to resemble seeds. The male with the most seeds might appear the most sexually viable, and therefore win over the female as a mate.

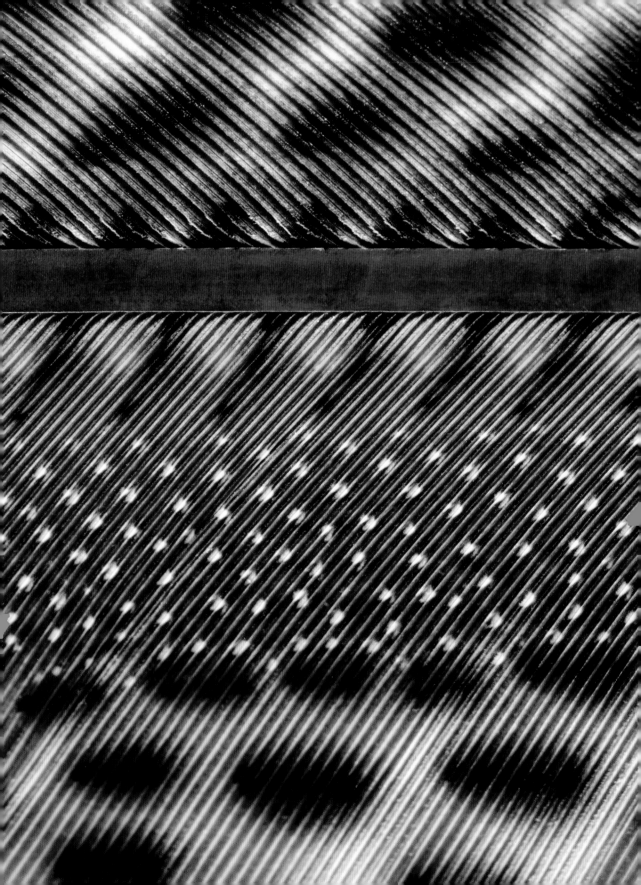

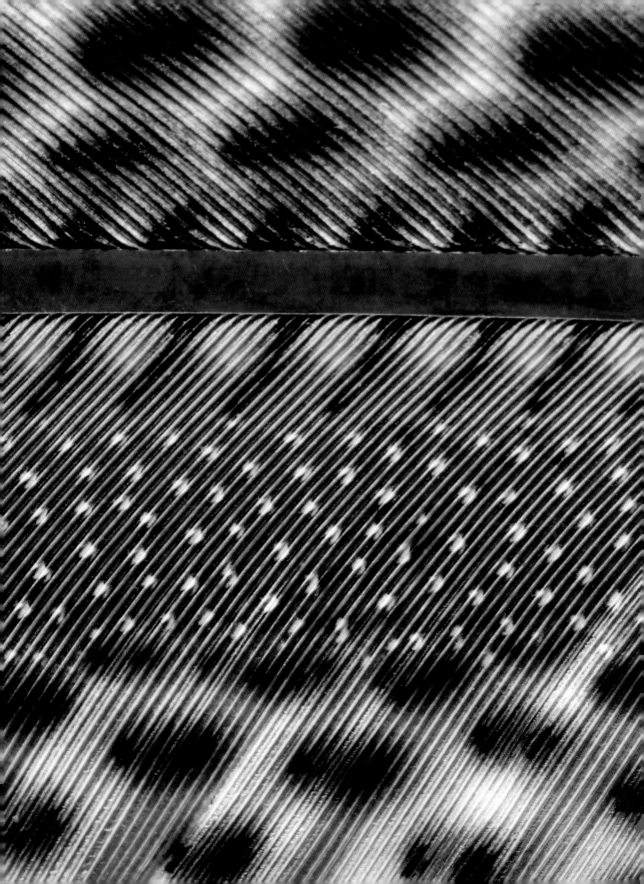

GREAT ARGUS

[detail]

—

A close-up of a feather from a female bird. The females are smaller with duller coloring and fewer occelli.

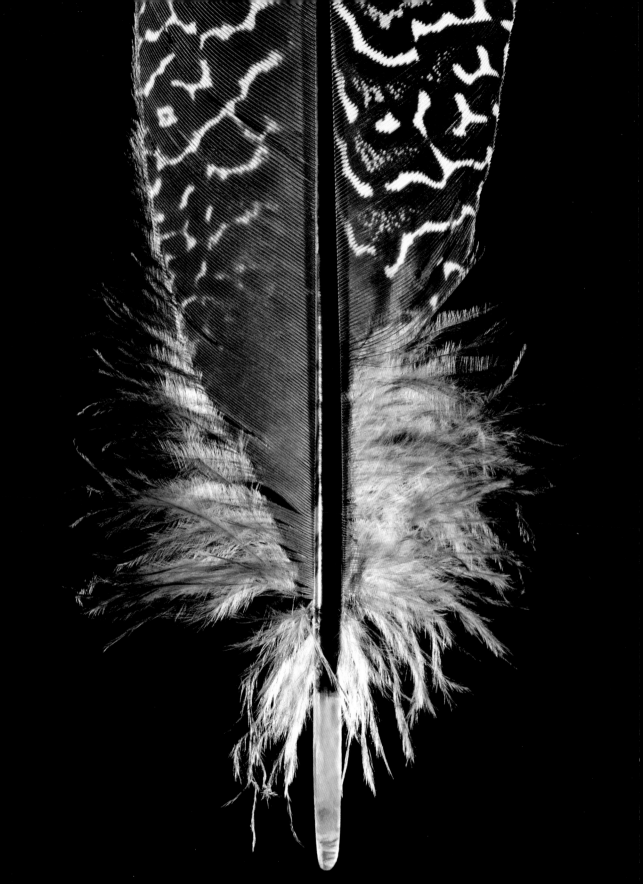

GOLDEN-HEADED QUETZAL

—

CENTRAL AMERICA AND NORTHERNMOST SOUTH AMERICA
PHAROMACHRUS AURICEPS

The vibrant feathers of the Quetzal have been sought after for hundreds of years. The Aztec and Maya of Central America once adorned their crowns with the green plumes of the local varietal, the Resplendent Quetzal. This particular feather comes from a species found mainly in the upland jungles of Bolivia, Colombia, Ecuador, Peru, and Venezuela. They are distinct from the other Quetzal species in that they have orange and gold head coloration and black underfeathers. The structural coloring of these feathers modifies light that hits their surface, allowing only green to escape, while the barbs near the base are a pigmentary red.

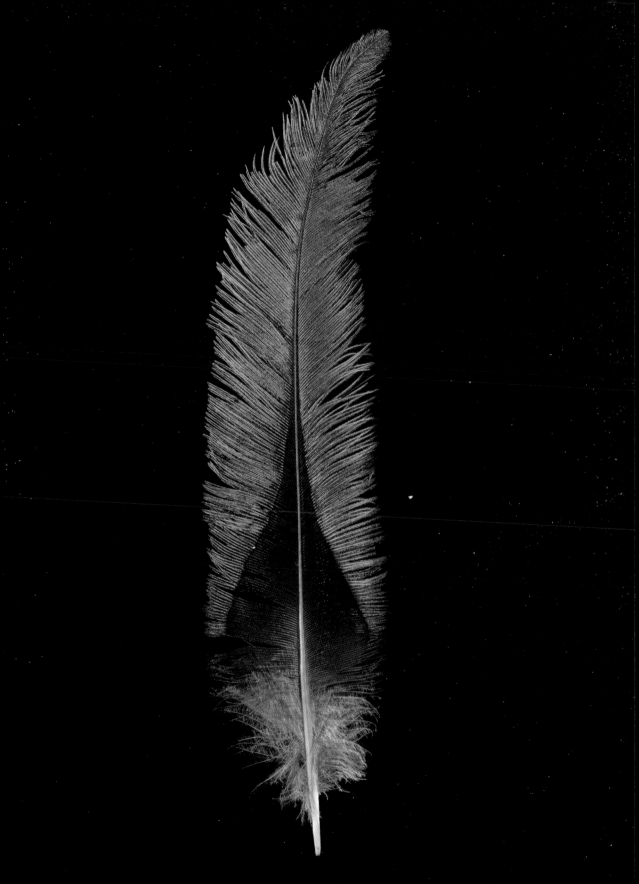

following spread:

BROAD-BILLED SANDPIPER

—

EASTERN AFRICA THROUGH AUSTRALASIA

LIMICOLA FALCINELLUS

This expanded view of the Broad-billed Sandpiper's feathers shows the wide variety of feather types that cover the bird's body, from leading-edge flight wings with a uniform shape to fluffy, irregular feathers that keep the Sandpiper warm and protect the bird's body from ocean spray in its habitat.

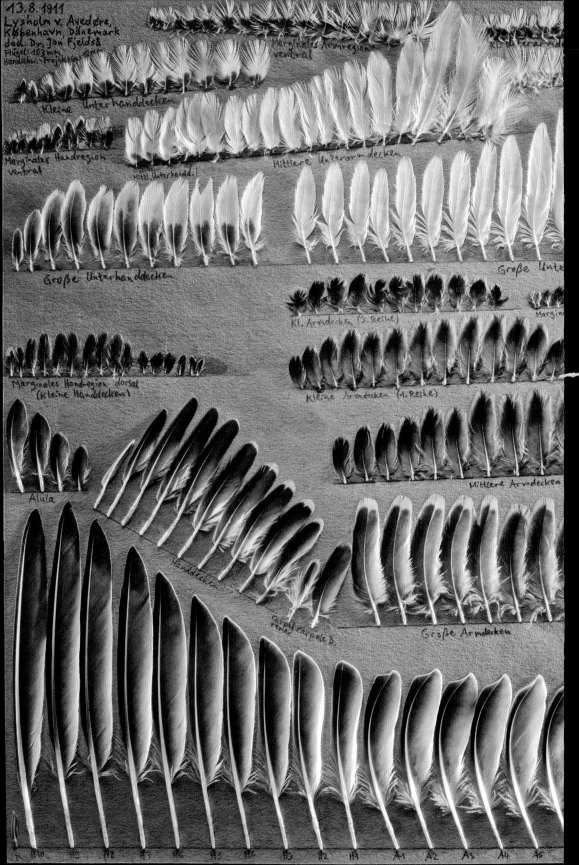

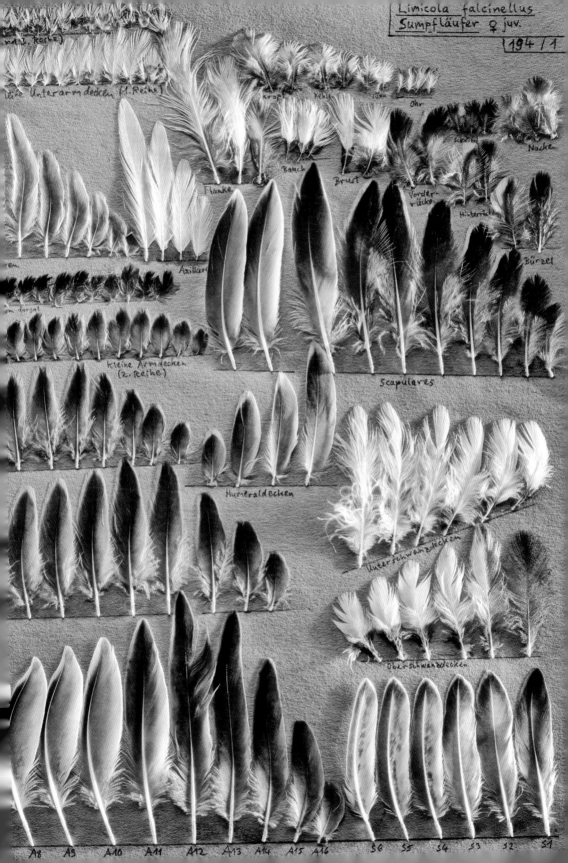

following spread:

LESSER SNOW GOOSE

—

NORTH AMERICA, ARCTIC CIRCLE
CHEN CAERULESCENS CAERULESCENS

The Lesser Snow Goose is a far-migrating member of the Anserini tribe of White geese. Their name, *caerulescens*, comes from a "blue" (cerulean) plumage morph through which they molt each year. This image displays the bird's high-altitude slotted wing, which allows the goose to fly long distances with high efficiency without too much cost in energy. The feather projection in the top-right portion of the image is a small "thumb" that the bird uses to change the way that wind passes over its wings, allowing it to alter its angle of attack.

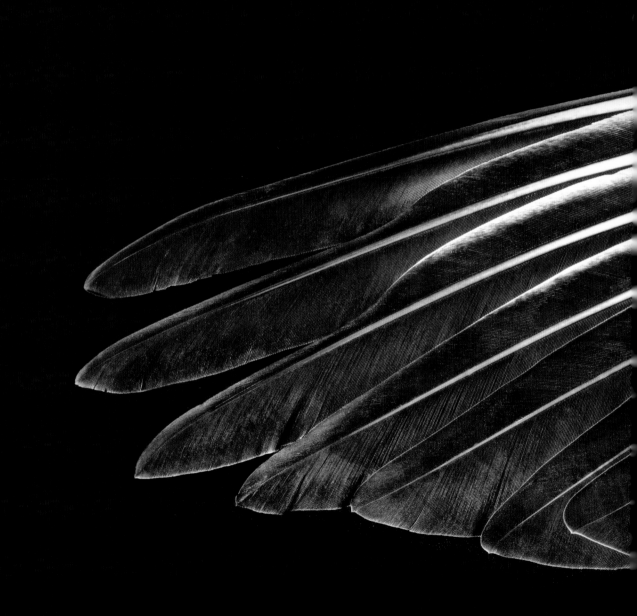

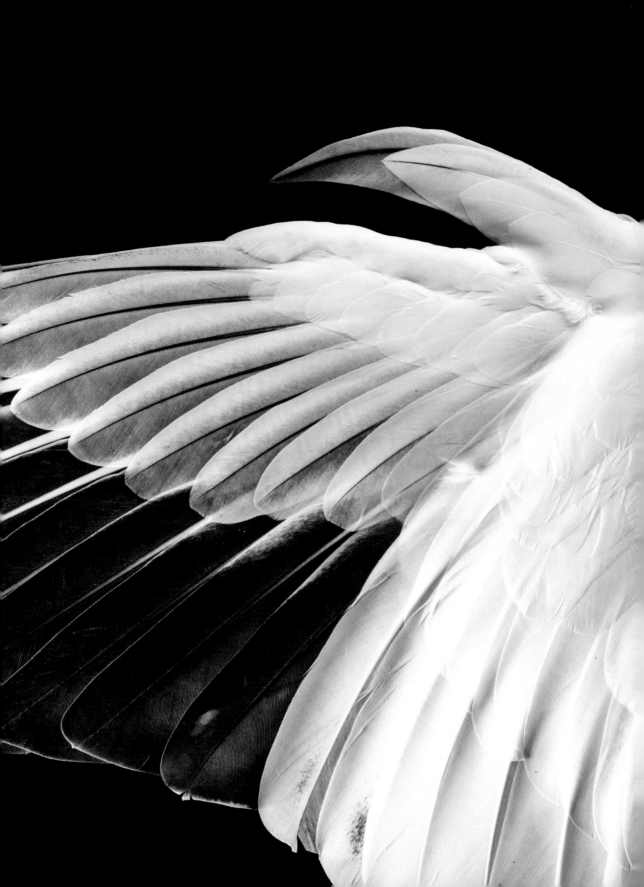

following spread:

LESSER SNOW GOOSE

[detail]

—

A detailed view of the *calamus*—the bottom portion of a feather's shaft—on the powerful wings of a Lesser Snow Goose.

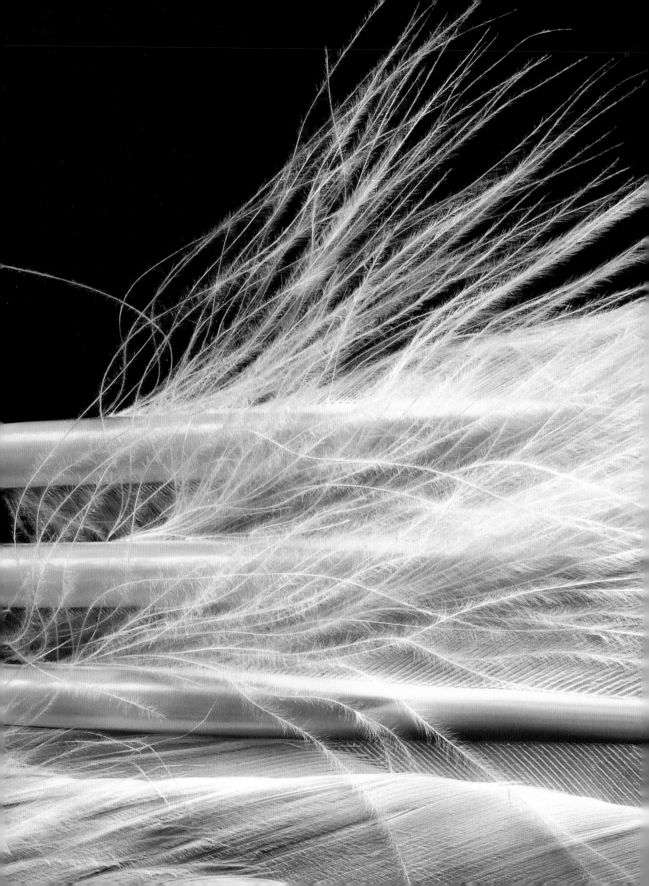

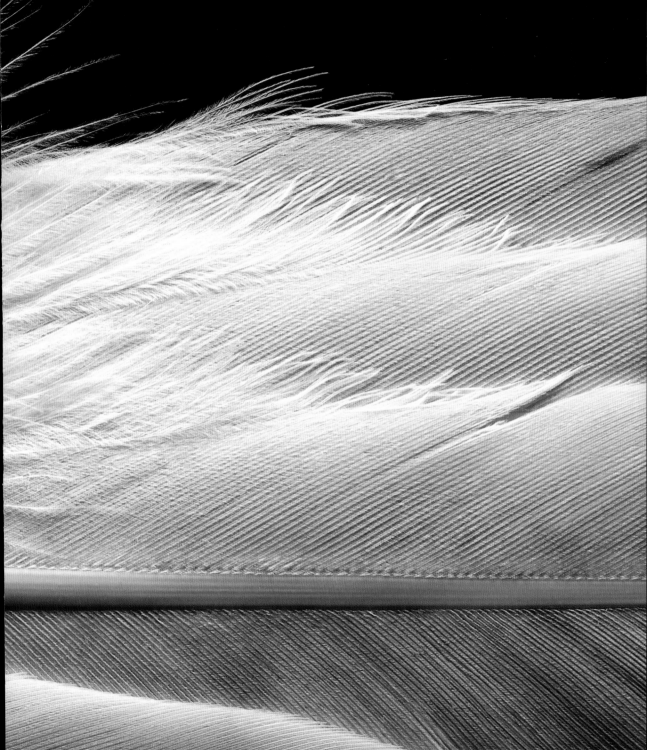

EUROPEAN GREEN WOODPECKER

—

EASTERN EUROPE AND WESTERNMOST ASIA

PICUS VIRIDIS

Though officially a member of the Woodpecker family, this bird doesn't spend much of its time drumming holes in wood. Rather than finding its food in trees, the bird forages for ants on the ground. Both sexes are greenish yellow with a bright yellow rump and red crown. The secondary feather seen here can barely be seen until the bird opens its wings.

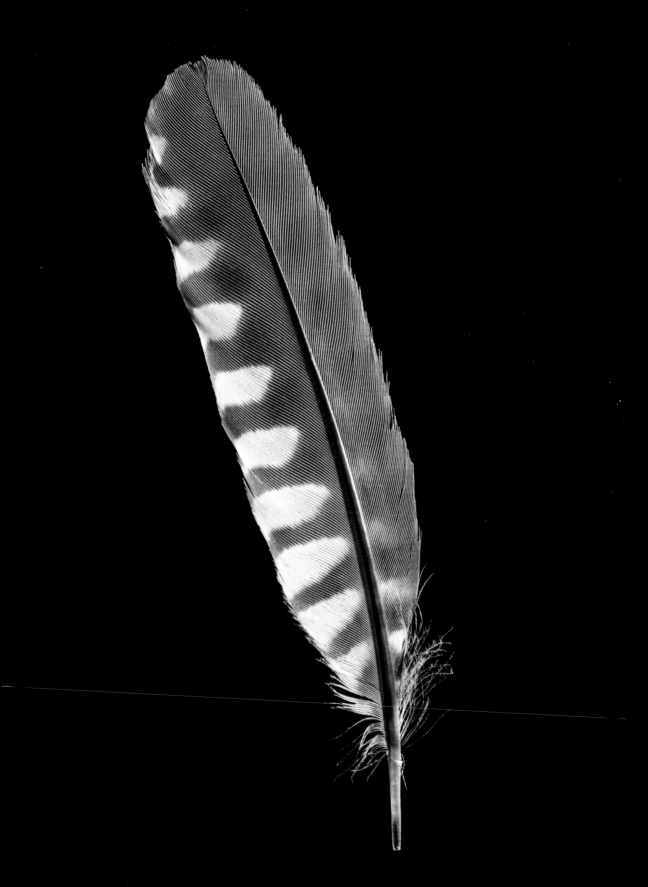

RED-SHAFTED FLICKER

—

CUBA, SOUTH AMERICA AND NORTH AMERICA, CAYMAN ISLANDS

COLAPTES AURATUS

A varietal of the common Woodpecker, the Red-shafted Flicker's feathers have developed to suit its environment. The notched margins of this bird's wings serve two purposes: the feathers allow for quick, articulate flight, and the stiff *rachis*—the feather's central shaft—allows the bird to hold itself against a tree as it burrows deep into the bark to find a quarry of small insects.

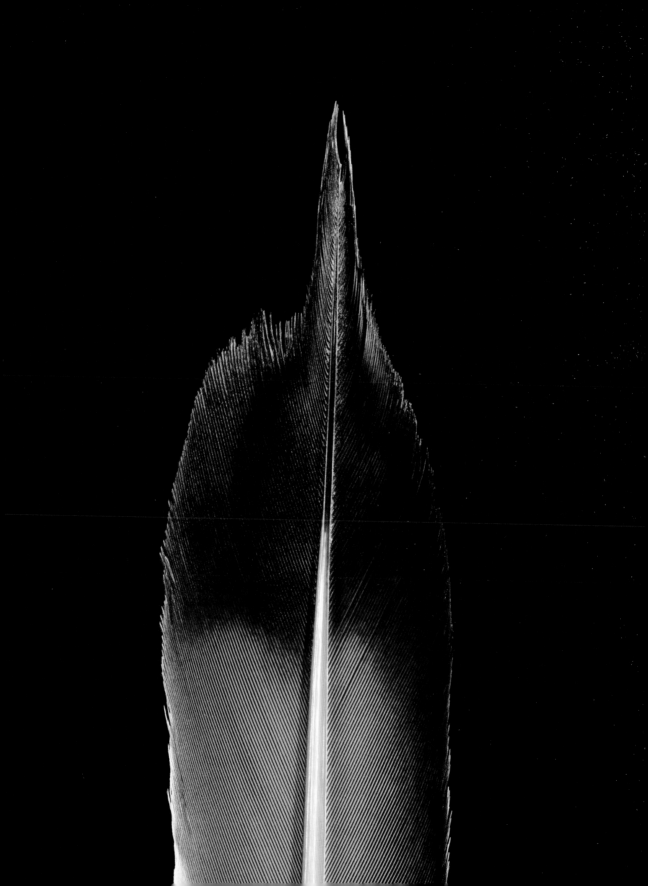

COMMON FLICKER

——

NORTH AMERICA

COLAPTES AURATUS

While most Woodpecker species are tree-bound, the Common Flicker has a tendency to forage near the forest floor. Here is shown a secondary feather with prominent notching on the tip. During flight, air is forced through the gap created by all the notched feathers in alignment, increasing the overall lift.

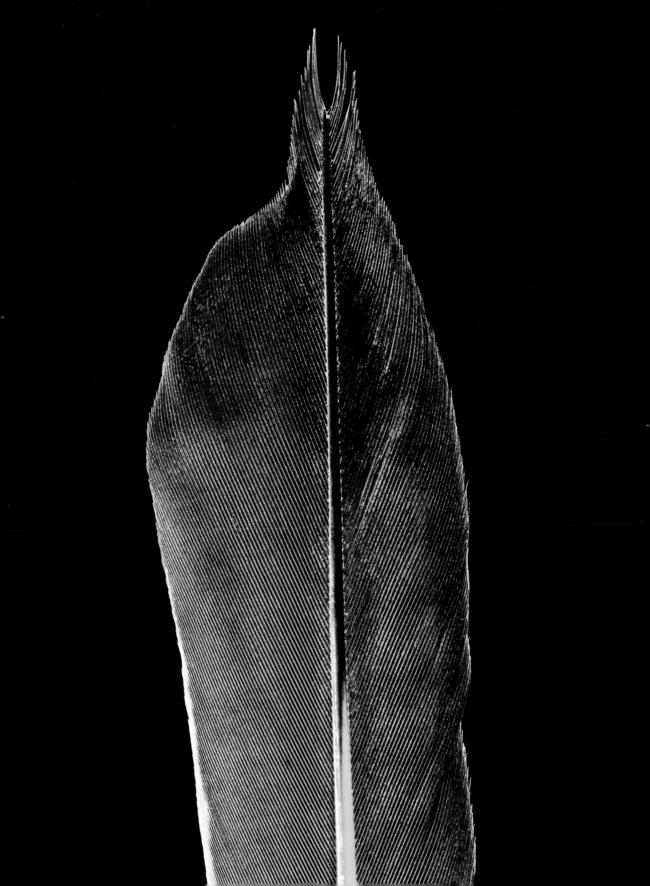

RED-CRESTED
TURACO

—

WESTERN ANGOLA

TAURACO ERYTHROLOPHUS

The Red-crested Turaco exhibits color through *porphyrins*, a modified collection of amino acids in their feathers. While porphyrins can produce a range of colors, including brown, green, pink, and red when exposed to UV light, they shine a brilliant red because of the organic compounds inherent to the acids.

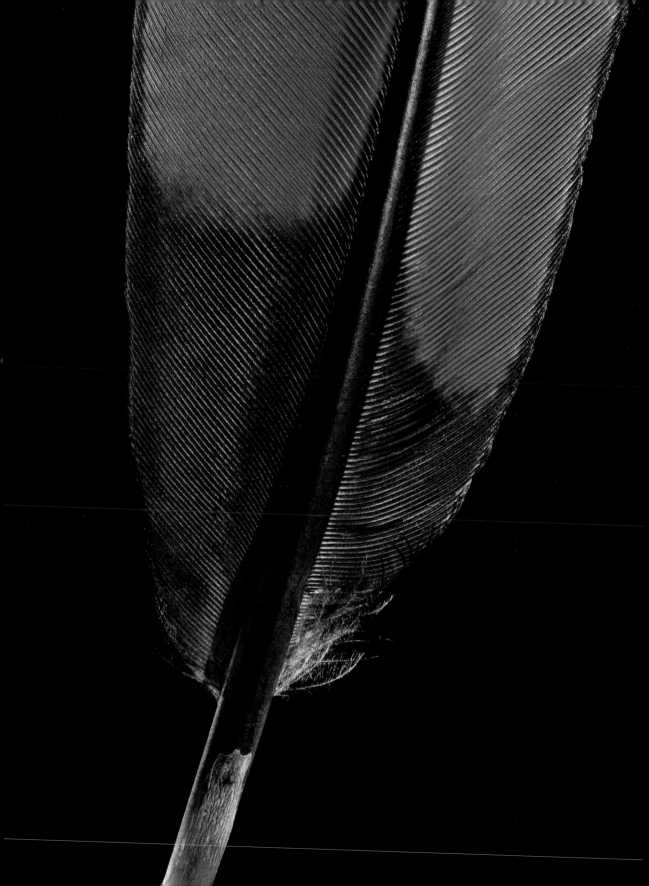

BLOOD PHEASANT

—

EASTERN HIMALAYAS
ITHAGINIS CRUENTUS

These relatively small Pheasants are strong runners, but not effective fliers. Their game-bird-shaped wings are designed only to maneuver through tight spaces in escape rather than for sustained flight. Male Blood Pheasants display a remarkable palette of colors; the female birds have more muted feathers.

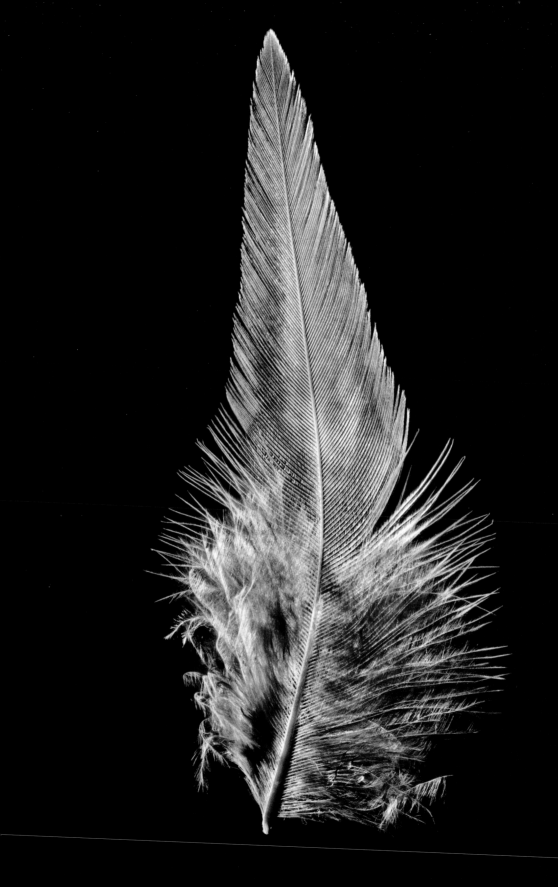

MANCHURIAN RINGNECK PHEASANT

—

ALPINE KOREA AND NORTHEASTERN CHINA

PHASIANUS COLCHICUS PALLASI

This bird is a variation of the Common Ringneck Pheasant. Pheasants display color-varied sexual dimorphism, which means males and females differ significantly in appearance. The females of the *Phasianus* genus are rather unremarkable in appearance, while their male counterparts display feathers in a symphony of colors intended to attract a mate.

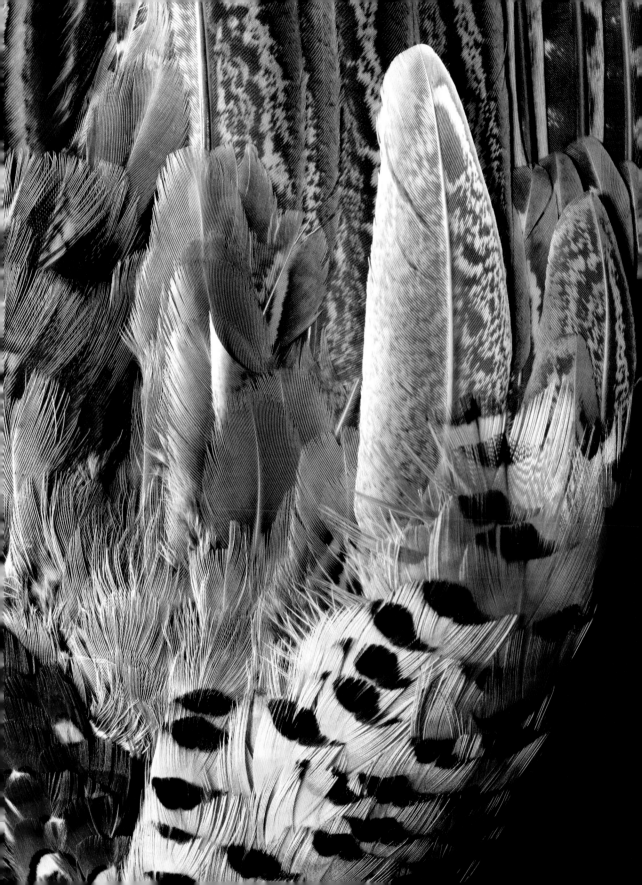

SILVER PHEASANT

—

SOUTHEAST ASIA, MAINLAND CHINA
LOPHURA NYCTHEMERA

Juvenile Silver Pheasants possess brown spots throughout their body. As the male birds age they develop a pure white morph, while the females remain brown. Originally found in Southeast Asia, the Silver Pheasant has gained popularity as a pet because of its calm temperament and nondestructive behavior in gardens.

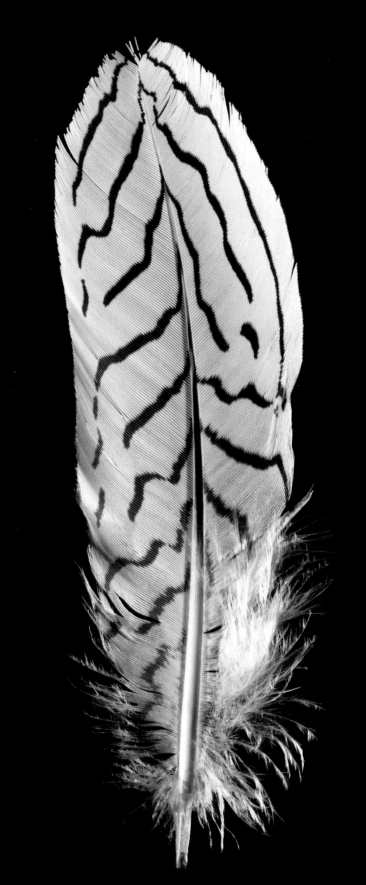

following spread:

SUPERB STARLING

—

EASTERN AFRICA

LAMPROTORNIS SUPERBUS

The Superb Starling's wing feathers are a bright, eye-catching green indicative of a structural coloration; color is produced by microscopically structured surfaces that interfere with and scatter visible light. These iridescent birds live in large flocks where females interbreed with multiple males for larger genetic diversity, while the males pair with a single female for life.

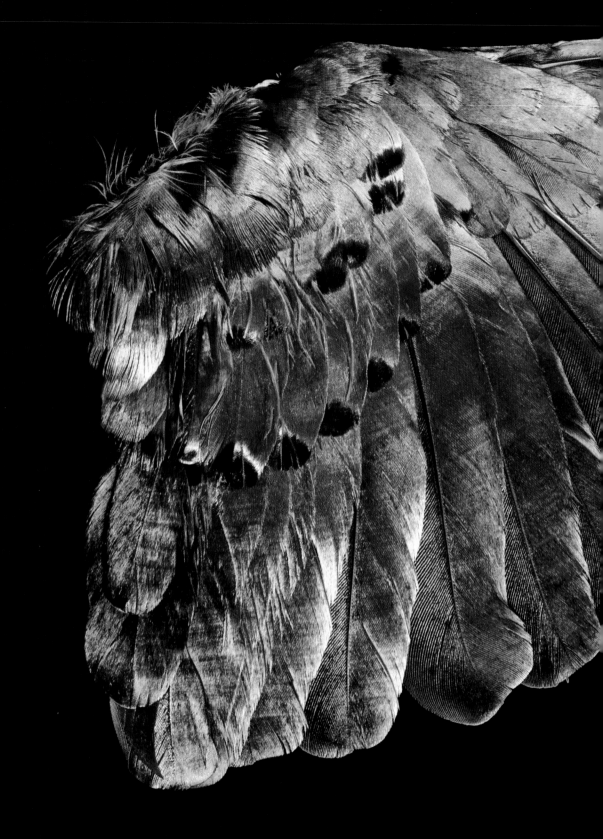

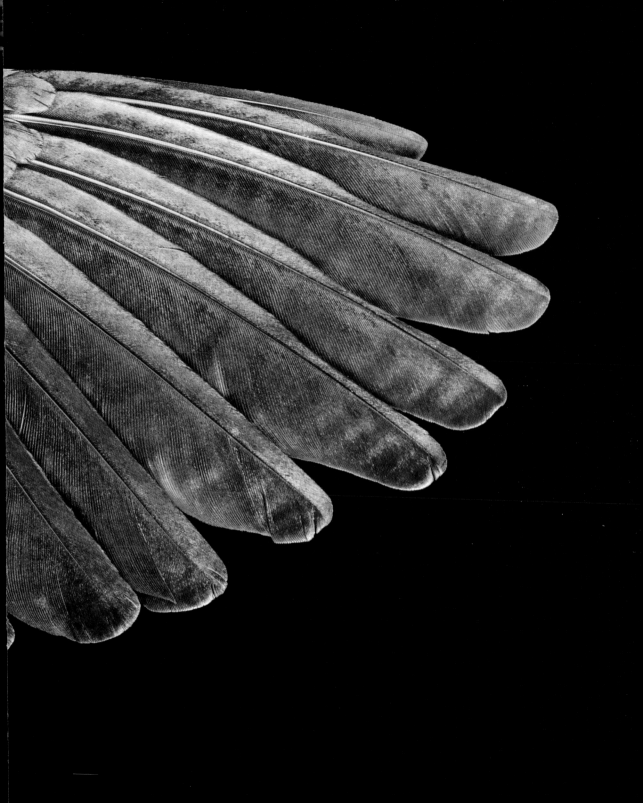

GOLDEN-BREASTED STARLING

—

EAST AFRICA, SOMALIA, ETHIOPIA, KENYA, AND NORTHERN TANZANIA
LAMPROTORNIS REGIUS

Also known as the Royal Starling, Golden-breasted Starlings are social animals that exhibit a behavior known as "cooperative feeding" wherein the larger social group of Starlings collectively nest and feed their young. Male and female birds share the same coloration, and the Starling's feathers grow more vibrant as the bird ages. The edges of the feather shown here appear iridescent, much like the feathers of a Peacock. Iridescent color is an indication of the feathers' structural color, which interferes with natural light.

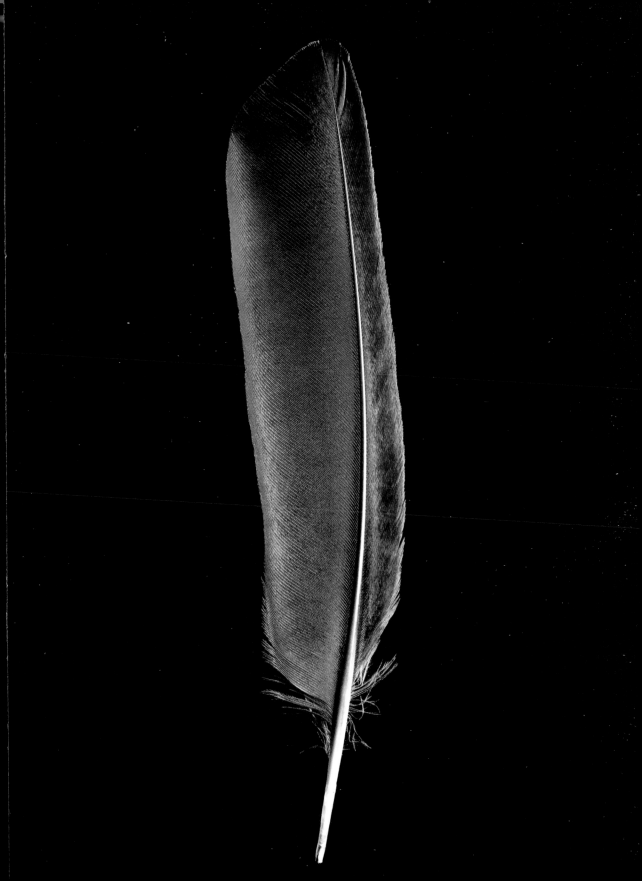

following spread:

OSTRICH

—

AFRICA

STRUTHIO CAMELUS

Also known as the Camel Bird, the Ostrich has one of the largest ranging distances of a terrestrial bird. The birds' powerful appendages allow it to reach speeds of 41 miles per hour. Their otherwise useless feathers can be used to adjust for balance while the bird is running.

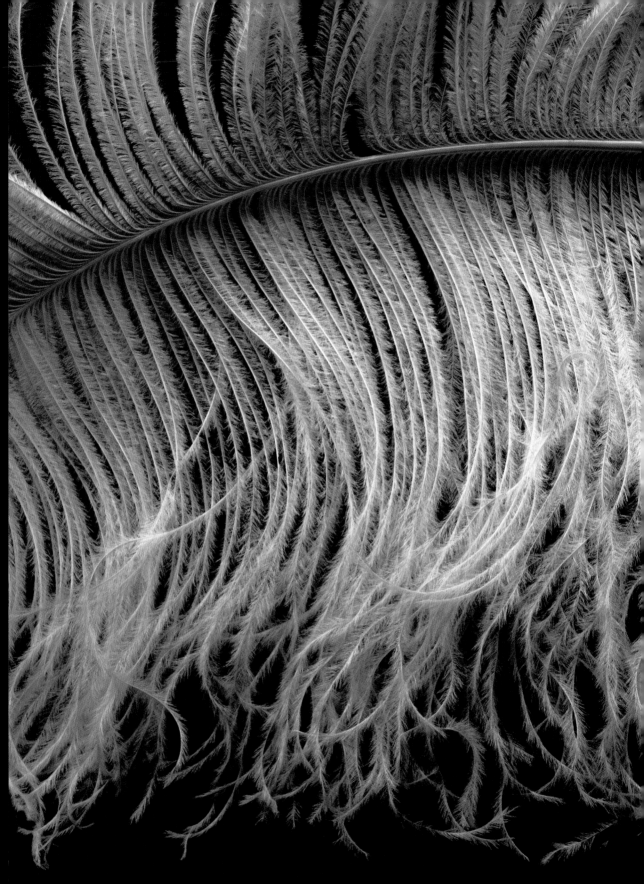

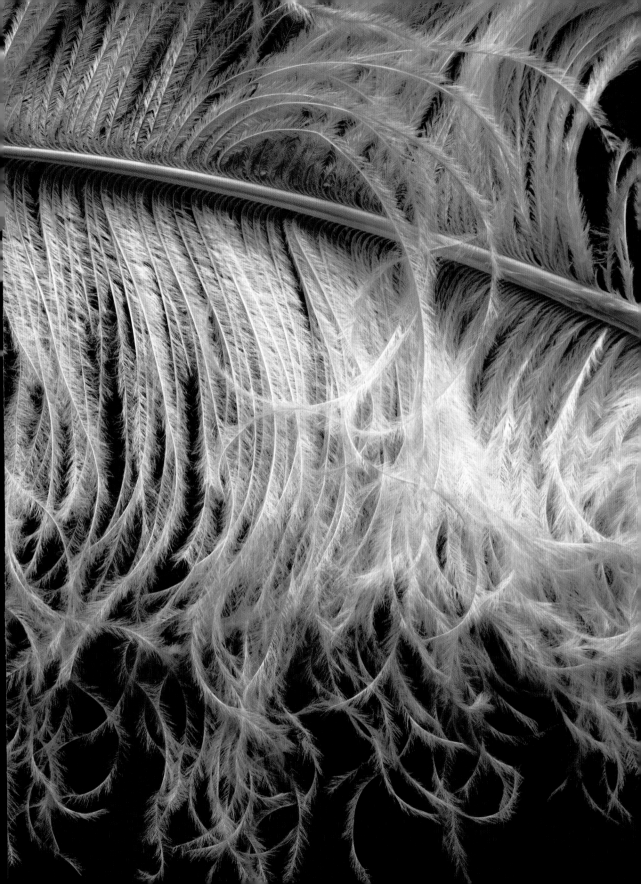

following spread:

OSTRICH CHICK

—

The chick's bristle feather pictured here is covered in a fine down that the bird will retain through adulthood. Though the adults may appear to be bare-skinned along their neck and legs, they have a fine network of hairlike feathers that cover their appendages.

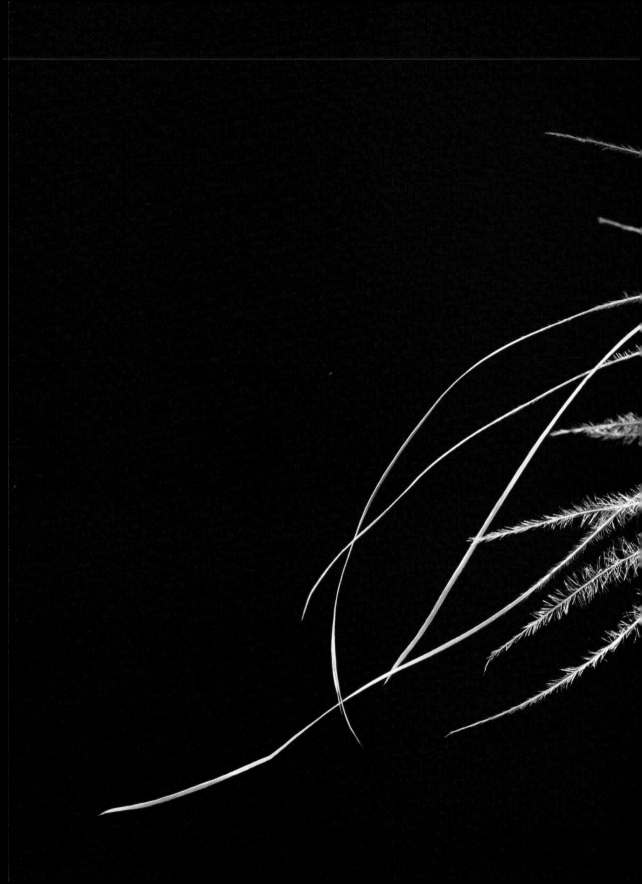

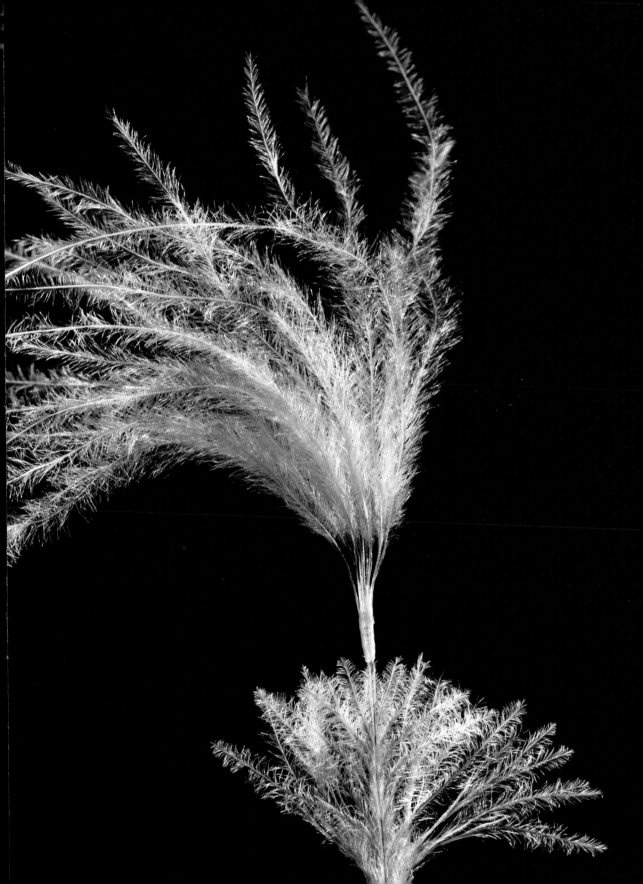

EURASIAN JAY

—

NORTHERN AND CENTRAL EUROPE

GARRULUS GLANDARIUS

The Eurasian Jay is far less colorful than its American counterpart, the Blue Jay, though they are just as noisy and inquisitive in nature. The flight range of the Eurasian Jay is much wider than that of the American Blue Jay, extending from India to the United Kingdom.

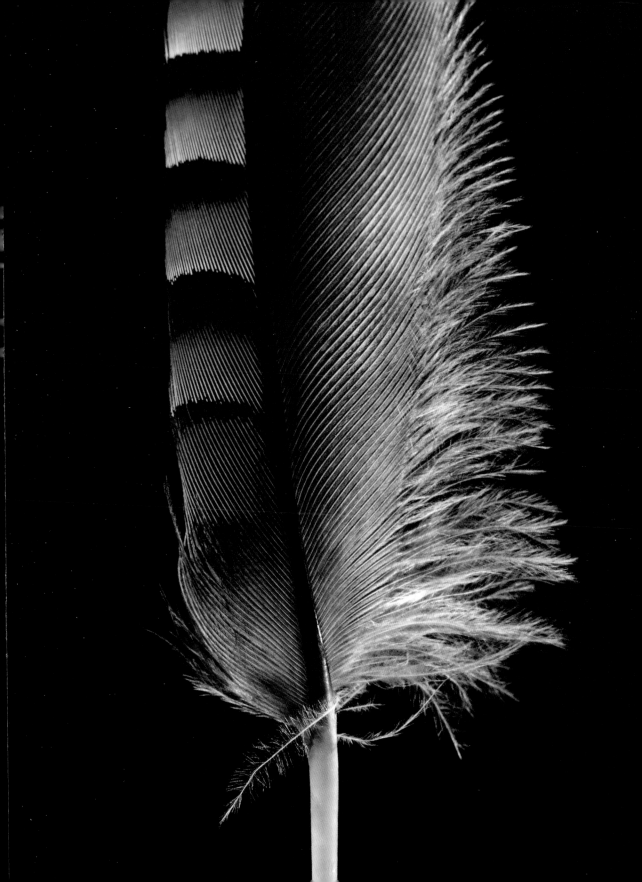

LITTLE BUSTARD

—

NORTHERN AFRICA THROUGH WESTERN ASIA AND EUROPE
TETRAX TETRAX

The only member of the *Tetrax* genus, the Little Bustard is the smallest of the Palaearctic Bustards. When threatened, the bird often uses its powerful legs to run away rather than fly. Like other Bustards, the males have a dramatic mating display—known as *lekking*—with foot stamping and leaping in the air. As of 2015, this bird was considered "Near Threatened" by the International Union for Conservation of Nature due to encroachment on their habitat.

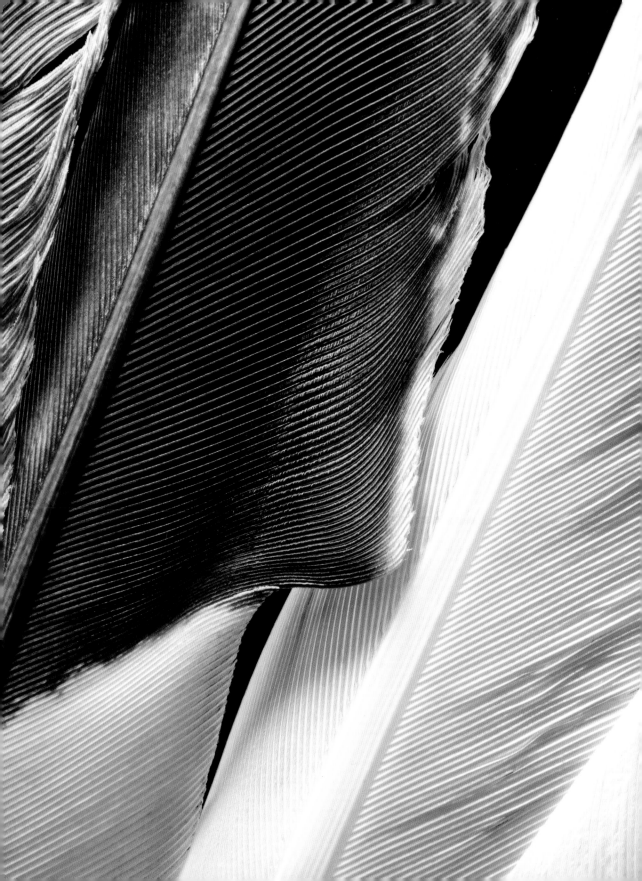

GRAY JUNGLEFOWL

—

PENINSULAR INDIA

GALLUS SONNERATII

If it weren't for its remarkable gold and black crest, the Gray Jungle-fowl would look very much like a common farm Chicken. Its colorful crest is made up of a collection of paper-thin feathers laid on top of one another.

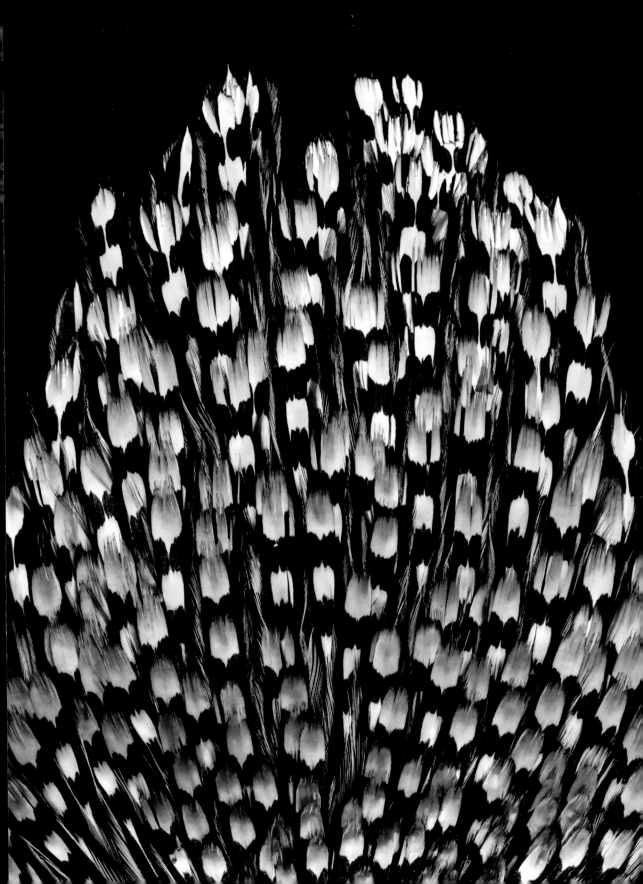

following spread:

NORTHERN FULMAR

—

ARCTIC CIRCLE
FULMARUS GLACIALIS

The Northern Fulmar is a stalwart inhabitant of the colder reaches of Earth. With sharp wings for faster flight, thick flight muscles, and waxen wings that repel water, the bird is well suited to its inhospitable environment. The Northern Fulmar also has the ability to spit a wax-ester solution on avian predators, matting their plumage and causing them to lose flight efficacy.

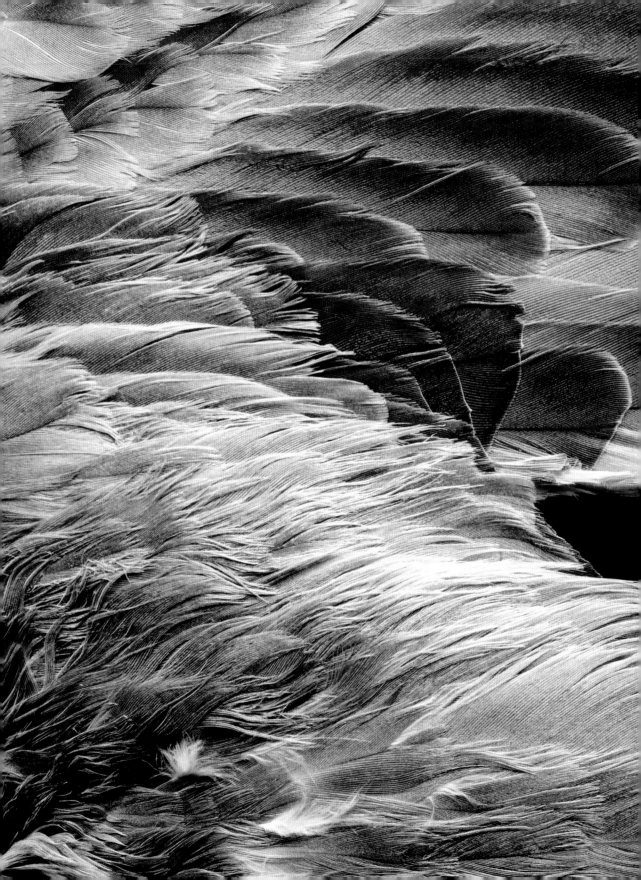

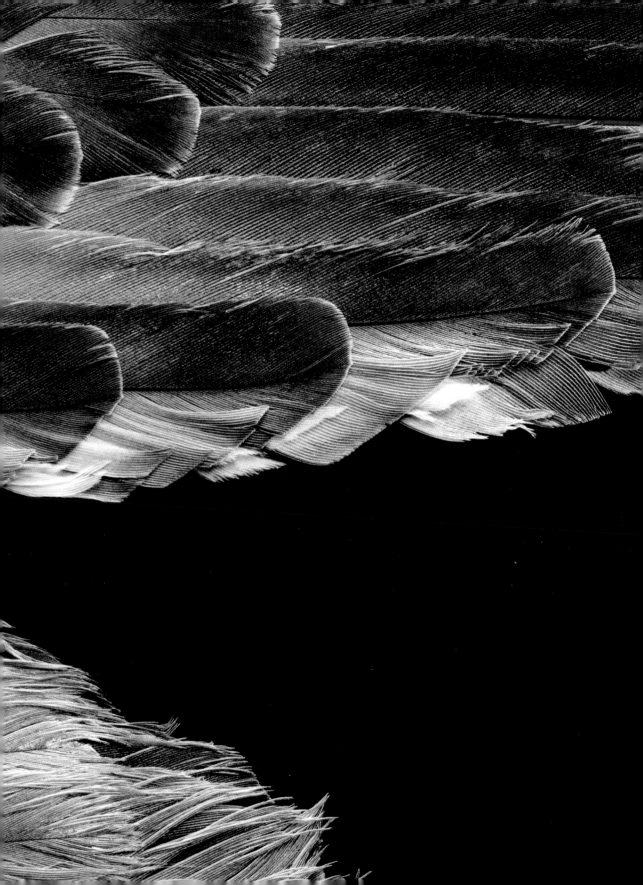

following spread:

MALLARD DUCK

—

NORTHERN HEMISPHERE
ANAS PLATYRHYNCHOS

Mallards are members of the Anatinae subfamily, a group of birds known as "dabblers" because they float on the surface of water, feeding just under the surface instead of diving for their food. Adult Mallard males possess green-blue head feathers separated from the rest of the body by a clean white ring about their neck, while the females' feathers are a more muted brown. Both the females and the males have an iridescent blue-purple group of *speculum feathers*—a patch of feathers visible on the anterior side of their wings.

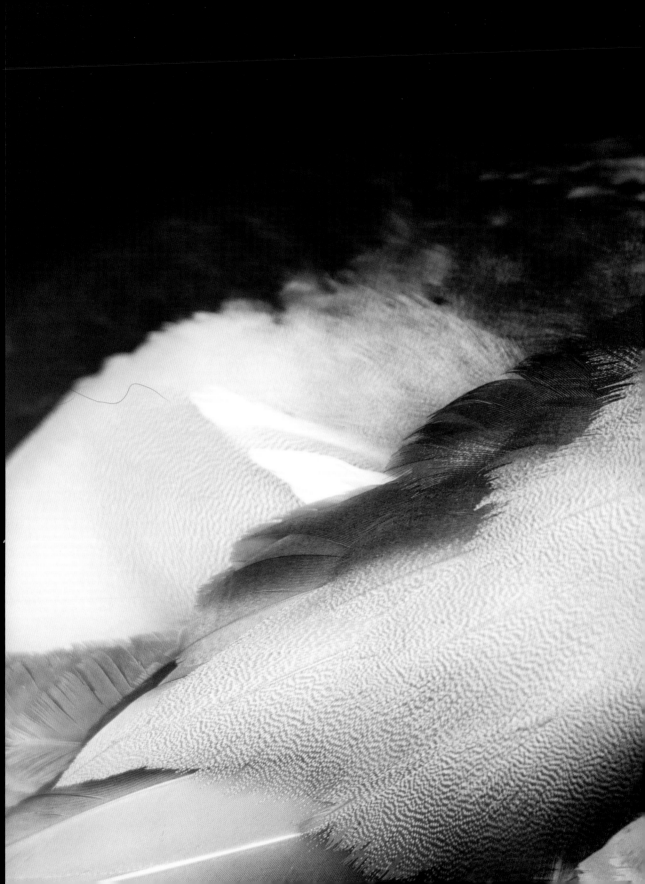

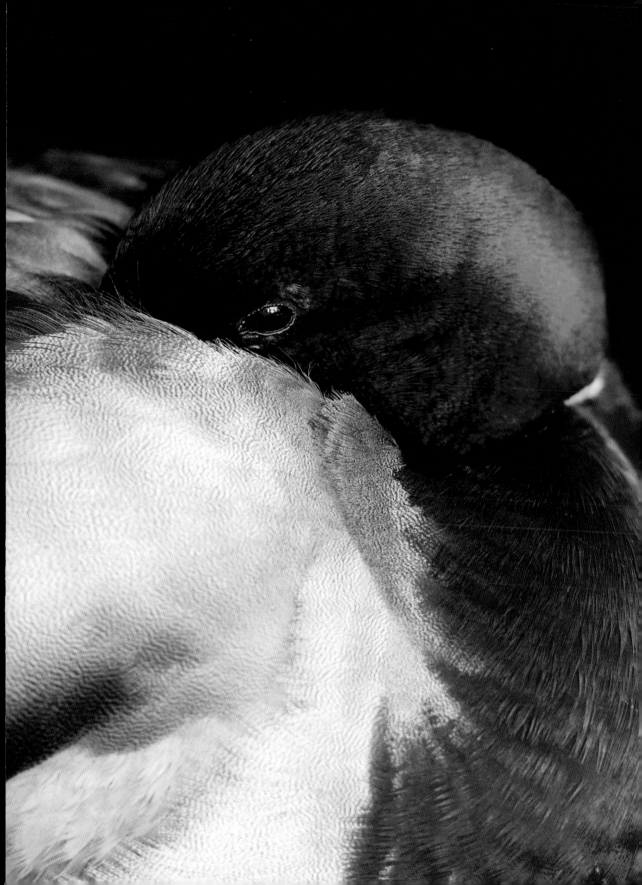

MANDARIN DUCK

—

ASIA, EASTERN EUROPE

AIX GALERICULATA

Male Mandarin Ducks—known as *drakes*—have "sails" on either wing. The orange and blue sails extend about two inches off the bird's back when it's floating or swimming in water.

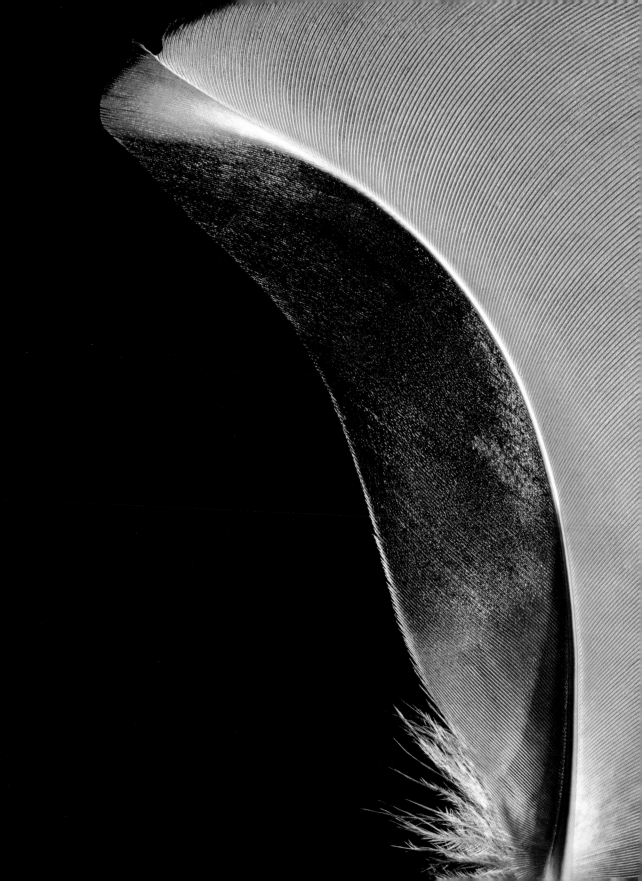

BLUE BUDGERIGAR

—

AUSTRALIA
MELOPSITTACUS UNDULATUS

The Blue Budgerigar's remarkable color is the result of selective breeding. The common Australian variant of Budgerigar has a yellow crest with a green chest and flank. But successive breeding has taken the bird to other color extremes, including the white and blue variant seen here.

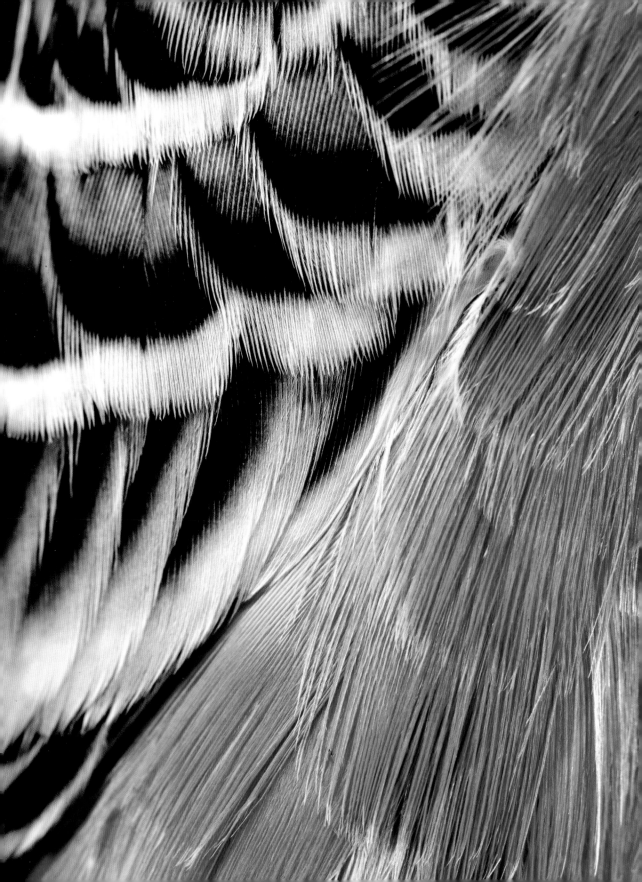

GREEN-BACKED TROGON

—

AMAZON, BRAZIL, TRINIDAD
TROGON VIRIDIS

Trogons belong to the Trogoniformes order, known for their hetero-dactyl feet, with two toes facing forward and the other two facing backward. Named for their astonishing tail feathers, the Green-backed Trogons have beautiful bold tail feathers indicative of a species that takes sexual display very seriously. While this feather may look broken at its end, the feather is truncated naturally.

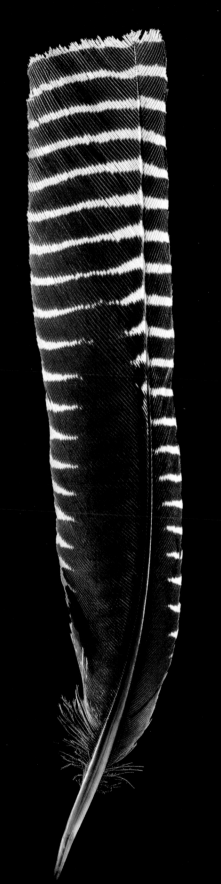

WHITE-CROWNED PARROT

—

CENTRAL AMERICA, MEXICO

PIONUS SENILIS

The White-crowned Parrot's intelligence and charm have made the bird a popular pet. Named for the white feathers that adorn the crown of its head, the tail feather seen here is the most colorful part of the bird's plumage.

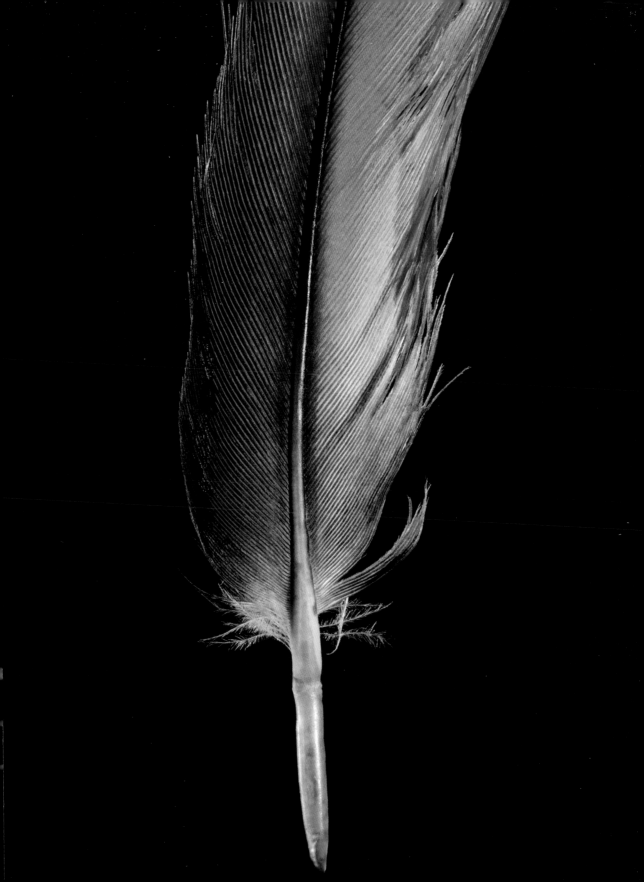

RED-CROWNED
PARROT

—

NORTHEAST MEXICO AND SOUTHERN TEXAS

AMAZONA VIRIDIGENALIS

Sadly, the Red-crowned Parrot may soon be extinct. Their numbers have slid drastically since the 1970s, with populations along the Rio Grande delta disappearing due to clear-cutting in their primary habitat in Tamaulipas, Mexico. As frugivores that rely on the ripe tree fruit not commonly eaten by or useful to humans, their decimated local habitats offer little alternative food.

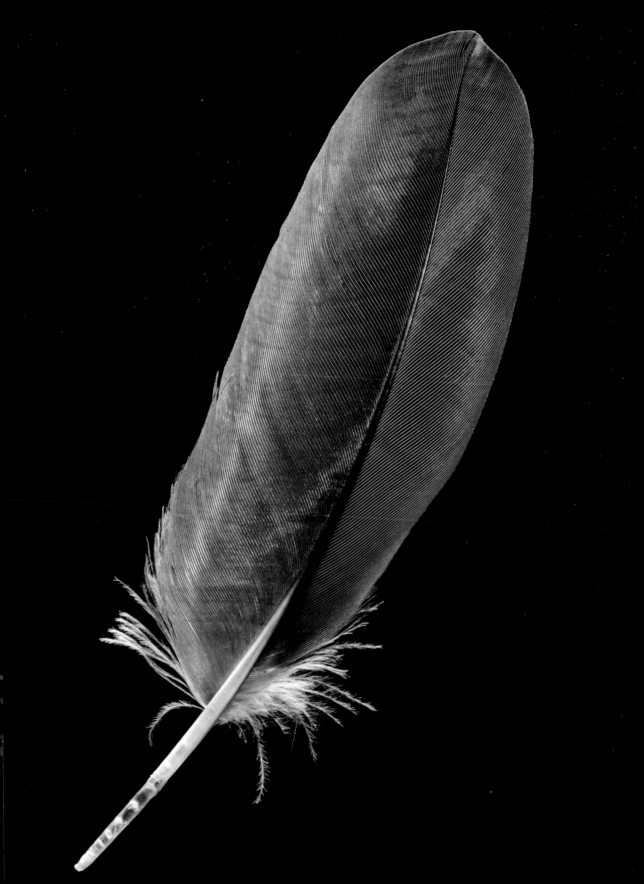

QUAKER PARROT

—

NATIVE TO CENTRAL AMERICA;
INVASIVE POPULATIONS ARE COMMON TO
AMERICAS AND PARTS OF EUROPE

MYIOPSITTA MONACHUS

Known for their vibrant green feathers, the Quaker Parrot, sometimes called the Monk Parakeet, is kept by many as a pet, but this comes at a price: feral populations of the Parrot are encroaching on non-native habitats and roosting in massive colonies in environments with no natural predators. They are the only parrot known to create stick nests, some so massive that they can house up to twelve pairs of Parrots.

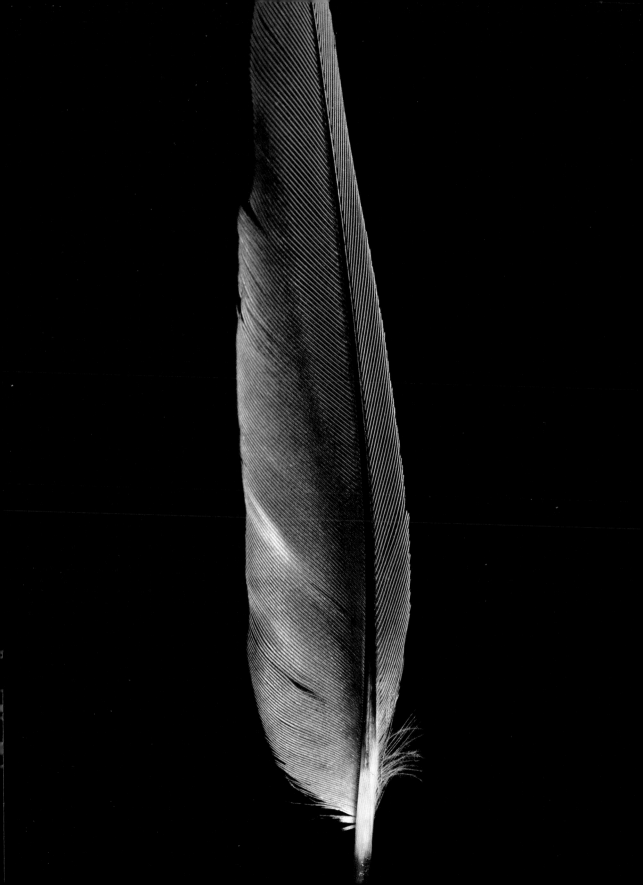

BLUE-FRONTED AMAZON

—

SOUTH AMERICA

AMAZONA AESTIVA

A popular pet that can learn up to fifty words and phrases, this member of the Psittacidae family is a curious and gregarious bird. The birds have more color-receptive cones in their eyes than other birds, a feature known as *tetrachromacy*. Though the feathers covering the male and female birds may appear very similar to the human eye, the birds' extra cones allow them to distinguish subtle differences in color.

Named for the blue patch above their eyes, the bird's body is covered in patched colors of green, red, and yellow. This secondary feather of the right wing shows off the brilliant yellow hidden in the bird's wings when it's not in flight.

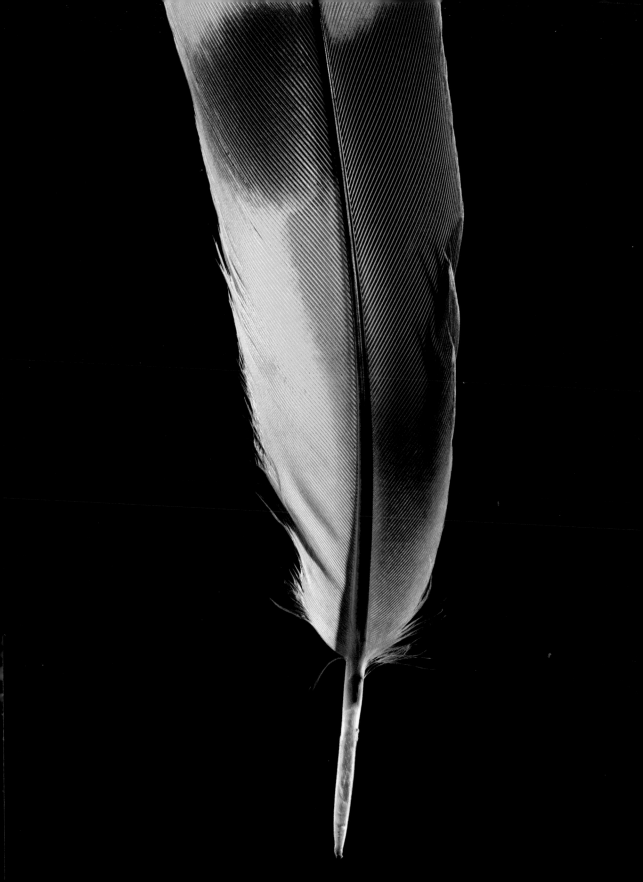

COMMON SWIFT

SOUTHERN AFRICA, EURASIA

APUS APUS

The Common Swift spends the majority of its life in the air. Because of this, the bird's wings have a small surface area designed to be flapped on a constant basis. Swifts demonstrate a bounding flight in which they never appear to be gliding but instead performing a kind of controlled fall.

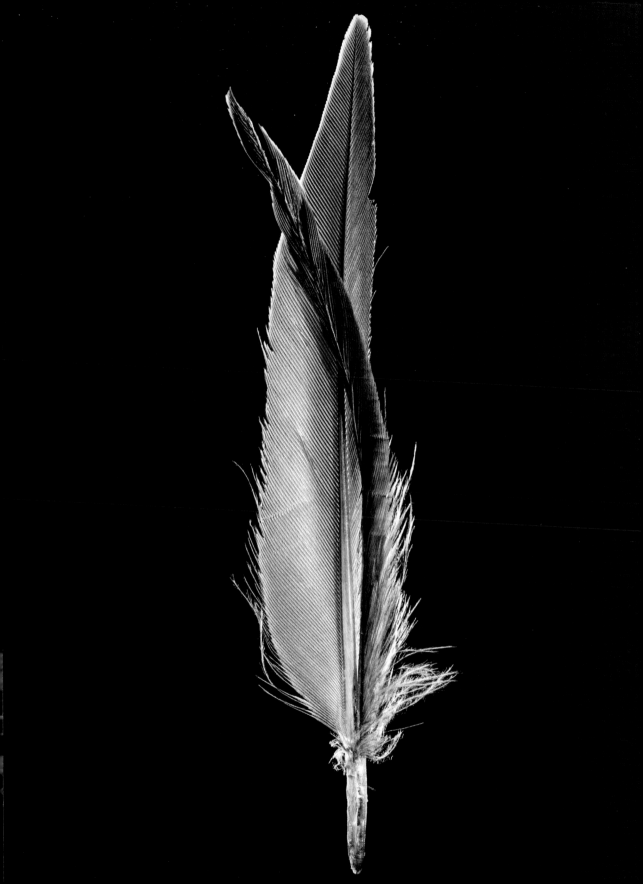

FORK-TAILED WOODNYMPH

—

JUNGLES OF SOUTH AMERICA

THALURANIA FURCATA

The term *furcata* in the Fork-tailed Woodnymph's taxonomic name refers to the bird's split tail, which has been known to be mistaken for little legs. The tail feather pictured here is two inches long, though the bird itself weighs only a few grams.

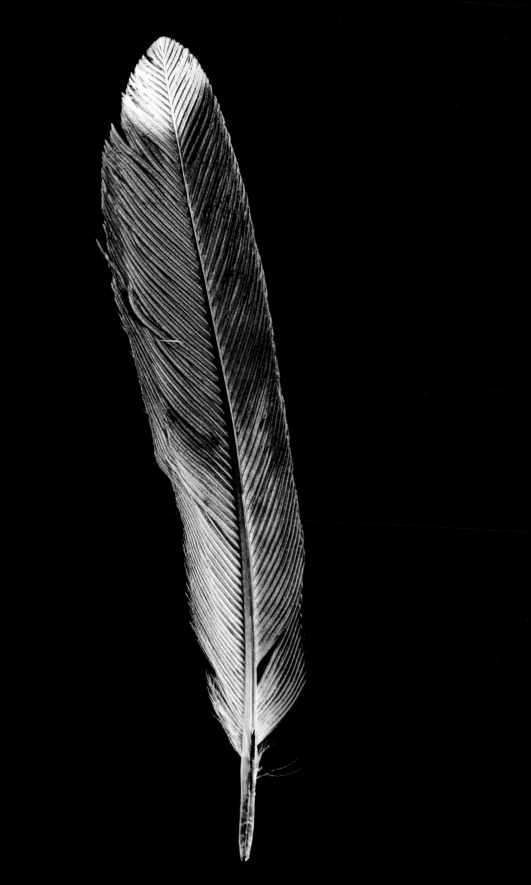

LILAC-BREASTED ROLLER

—

SUB-SAHARAN AFRICA, ARABIAN PENINSULA

CORACIAS CAUDATUS

A territorial bird, the Lilac-breasted Roller will defend its nest at all costs. The bird prefers to perch on top of trees, poles, and other high vantage points where it can spot predators from afar. The male and female birds have the same coloring and the juvenile birds look very similar to their adult counterparts, though the adults grow long tail feathers. This photograph shows the bird's vibrant blue secondary wing feathers, a stark contrast to the pastel orange of the Roller's back.

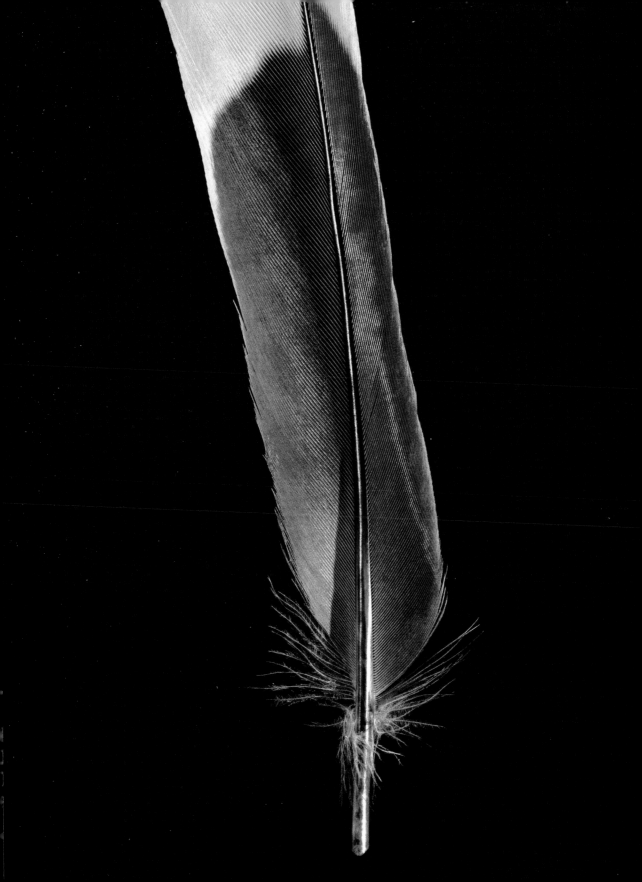

INDIAN ROLLER

SOUTHERN INDIAN SUBCONTINENT

CORACIAS BENGHALENSIS

Like its relative the Lilac-breasted Roller, this member of the *Coracias* genus is best known for its elaborate courtship displays. To attract a mate, the Indian Roller dips and rolls through the air, displaying its brilliant blue feathers, best seen in the undersides of its wings.

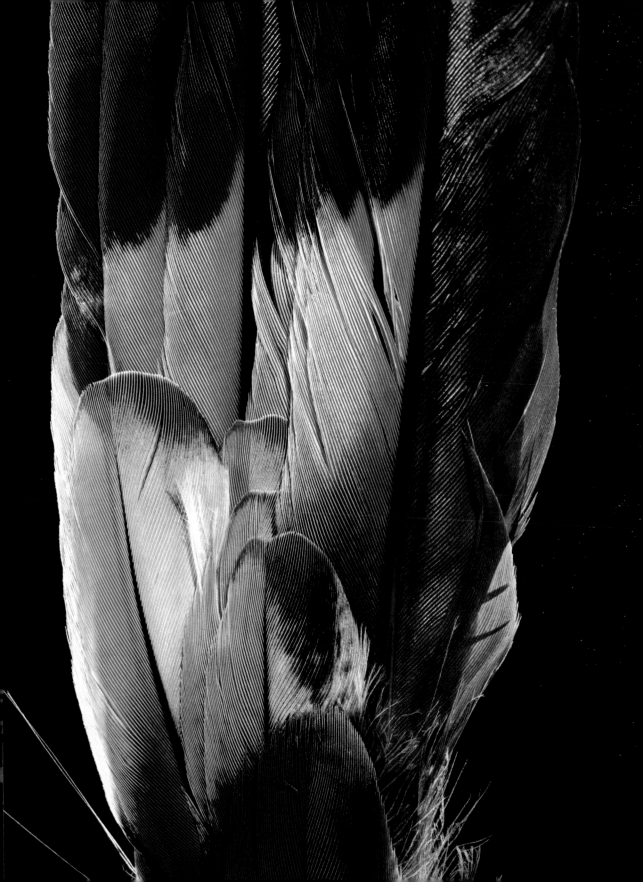

RED-BILLED
BLUE MAGPIE

—

WESTERN HIMALAYAS, CHINA THROUGH VIETNAM

UROCISSA ERYTHRORHYNCHA

Like most magpies, the Red-billed Blue Magpie has a penchant for mischief and curiosity, sometimes even stealing eggs and chicks from the nests of other birds. The bird's wing is designed for quick and sudden flight—its feathers have small notches along the leading edge of the structure, allowing the plumage to sit snugly within the mask of other feathers.

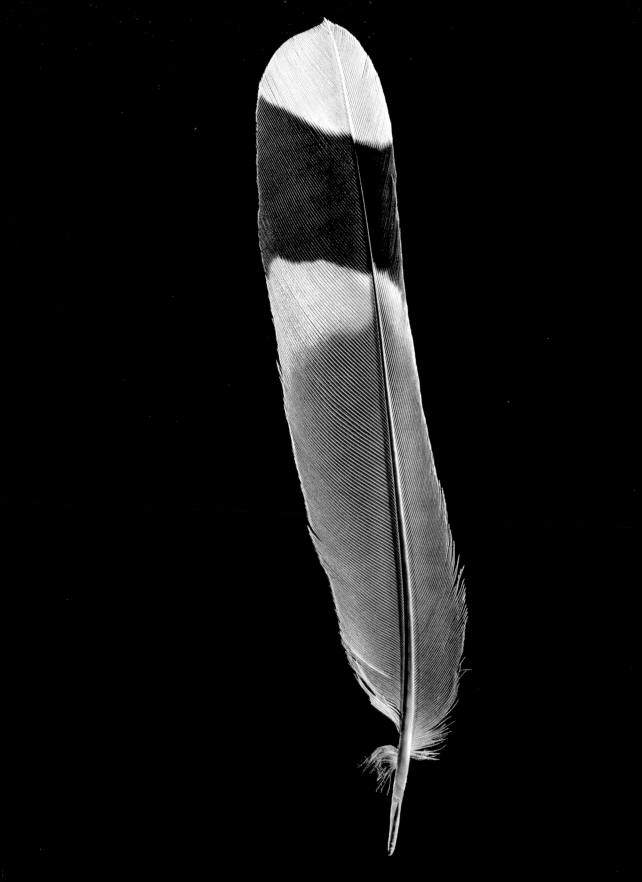

SPOTTED EAGLE-OWL

—

HORN OF AFRICA
BUBO AFRICANUS

The downy contour feathers from the breast of a Spotted Eagle-owl—
also known as the African Eagle Owl—have no flight properties; their
only purpose is to provide the bird with insulation during cold nights
in the African desert.

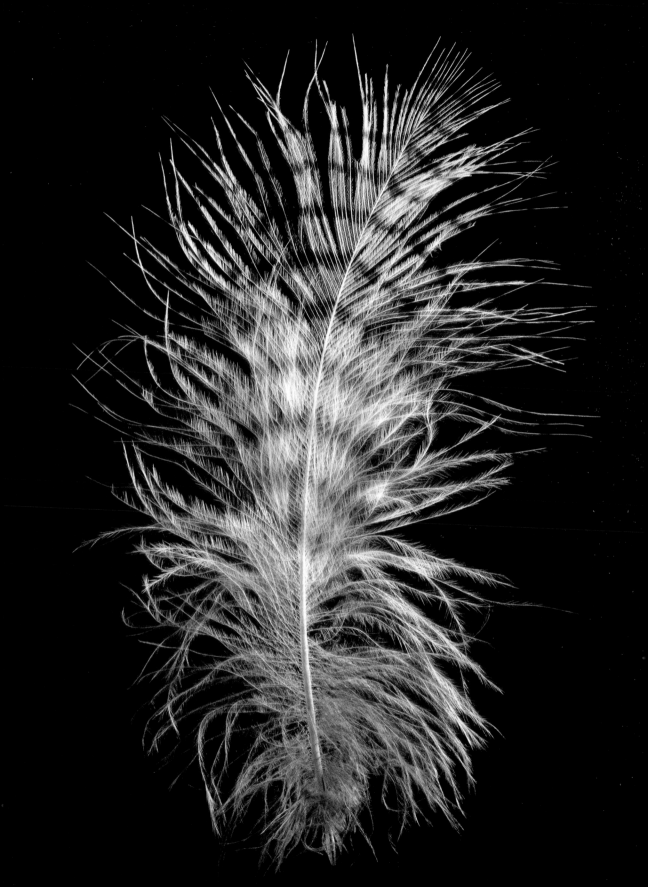

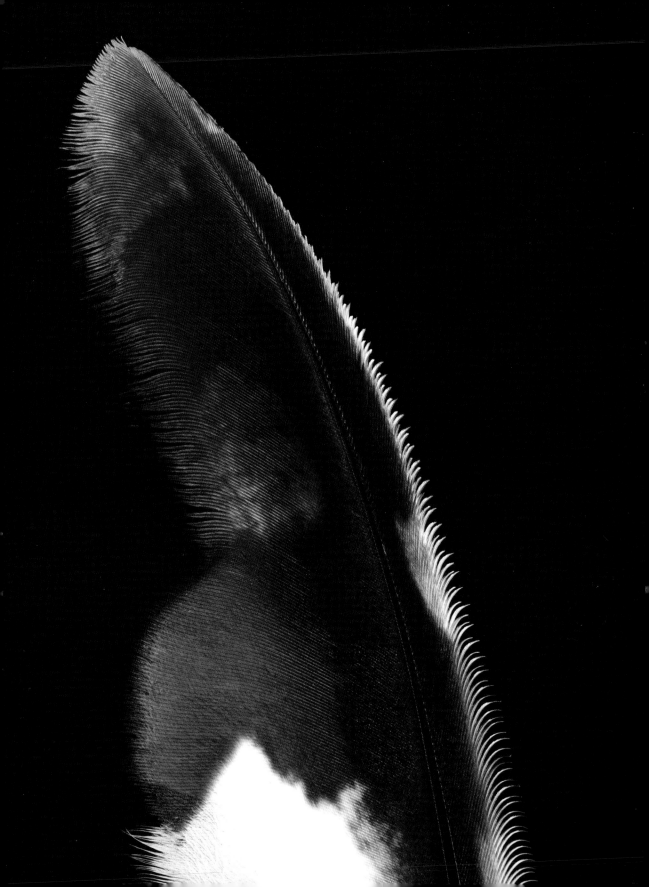

SPOTTED EAGLE-OWL
[detail]

━

The leading edge of this left-wing primary feather has a serrated edge, while the trailing edge is purposefully tattered, dampening the sound of their wings as they fly through the air as they hunt for insects and small animals. This design costs the bird some speed, but in the dark of night, silence is the most important weapon that the bird possesses.

UNIDENTIFIED OWL

—

Down and covert feathers like the Owl feathers seen here create a warm air pocket between the bird's body and the surrounding environment, allowing the Owl to insulate itself and maintain its body temperature.

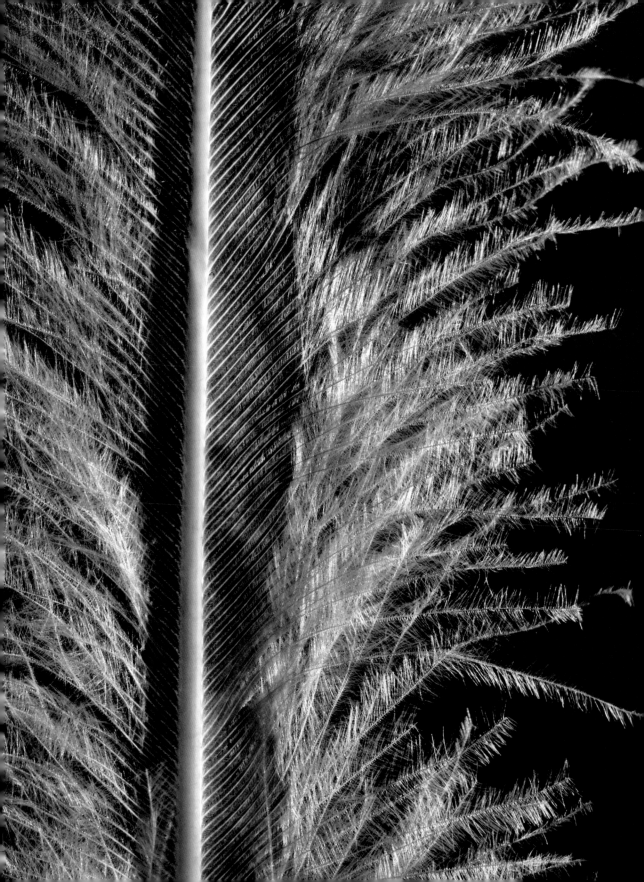

SOUTHERN CASSOWARY

INDONESIA, NEW GUINEA, NORTHWESTERN AUSTRALIA

CASUARIUS CASUARIUS

The prehistoric-looking Southern Cassowary is a member of the *ratites* group, a collection of large, flightless birds that lack the flight "keel" on their sternum found in birds with functional wings. The Cassowary is known to be shy but vicious when provoked, attacking and often disemboweling foe with its blade-like claws. Without the power of flight, their feathers serve mostly as insulation and protection from the elements.

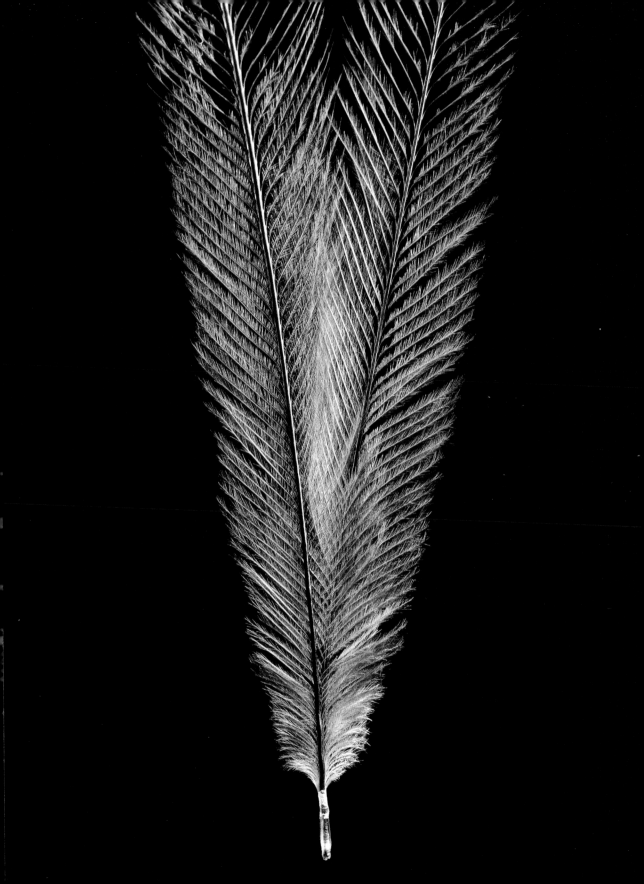

following spread:

SOUTHERN CASSOWARY

[detail]

—

The Southern Cassowary's feathers are formed very differently than those of birds whose feathers are oriented toward flight. As seen in this image, the feathers do not stick to one another because they do not need to be streamlined or lie against one another neatly, as flight feathers do.

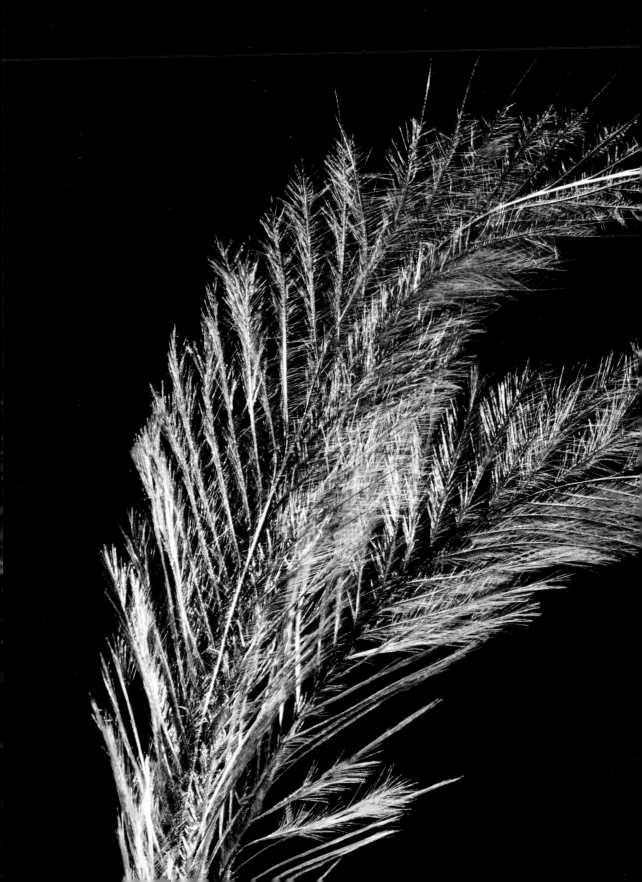

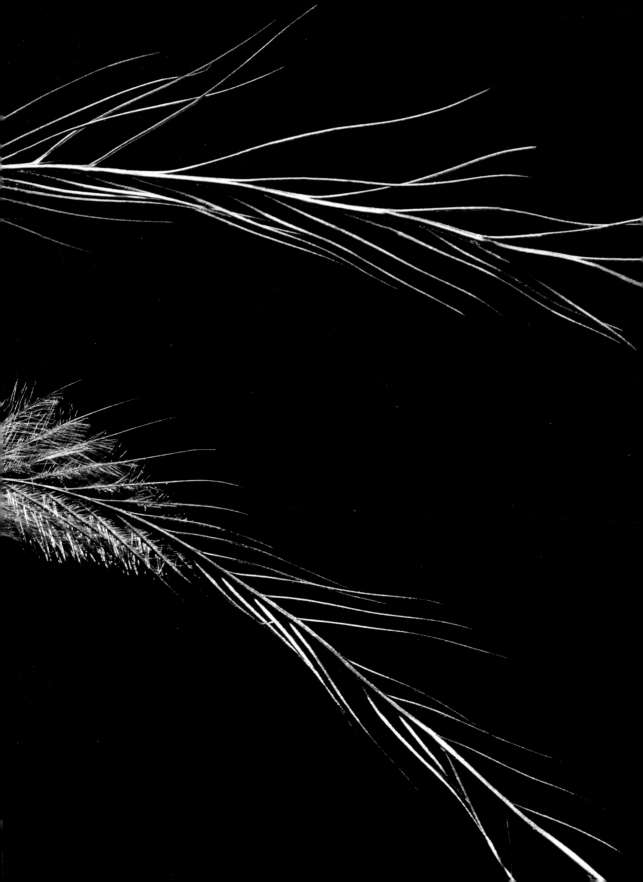

following spread:

SUNDA MINIVET

—

JAVA, INDONESIA

PERICROCOTUS MINIATUS

Minivets are small, delicate-looking birds with long tails. The multiple secondary wing feathers seen in this image are roughly five times the size of the Sunda Minivet's actual feathers. The plumage shown in this scaled image are arranged in order, giving us a better understanding of how each feather contributes to the overall structure of the wing.

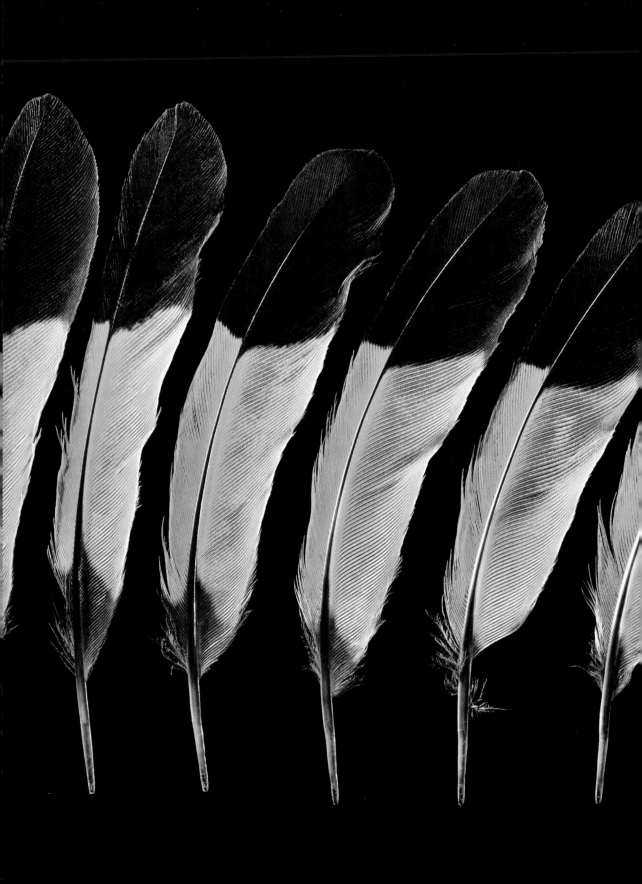

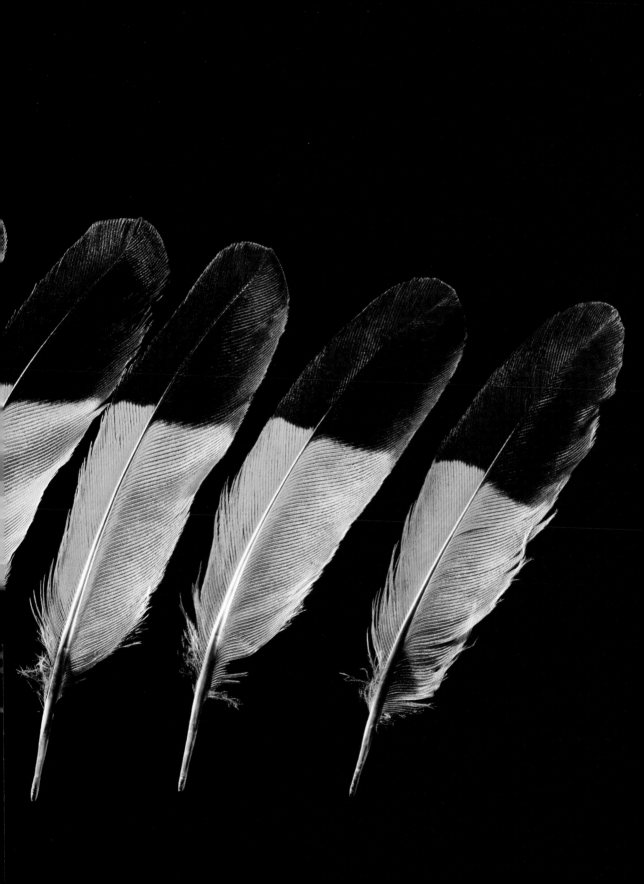

INDIAN PEAFOWL

—

NATIVE TO SOUTH ASIA, BUT INTRODUCED THROUGHOUT THE WORLD
PAVO CRISTATUS

The male birds—more commonly known as Peacocks—may well be one of the world's most recognizable birds. Their extravagant tail feathers, made up of elongated upper tail coverts, are some three times longer than the length of the bird itself. Their iridescent plumage is an example of structural color—the feathers are actually brown, but their structure interferes with light, making them appear blue, green, and turquoise.

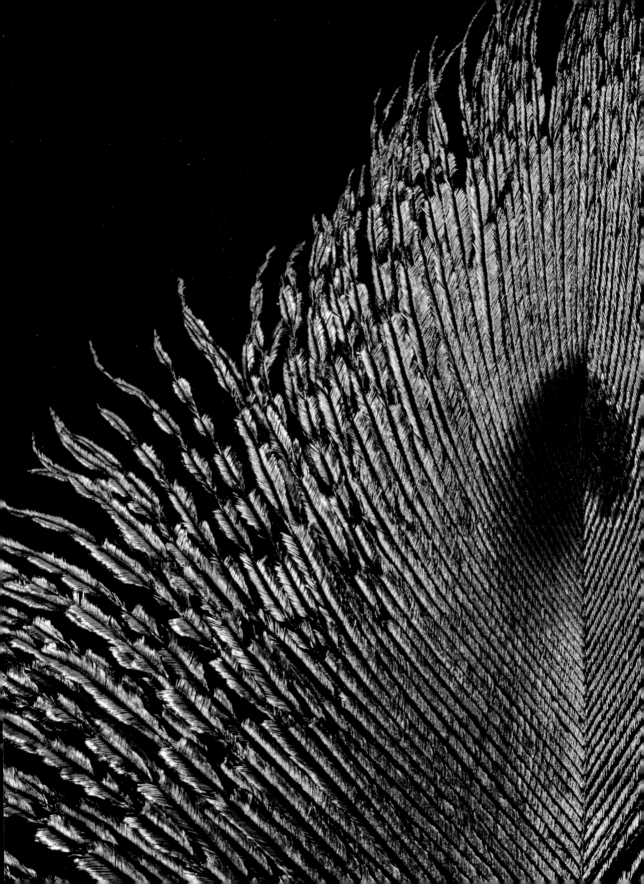

GREY
PEACOCK-PHEASANT
—

SOUTHEAST ASIA THROUGH NORTHEAST INDIA

POLYPLECTRON BICALCARATUM

The largest of the Asiatic Pheasants, the Grey Peacock-Pheasant sports tail feathers dotted with ocelli—round markings that look like an eye—that appear to change color in different light. During the male bird's mating dance, he directs his colorful feathers toward the intended female.

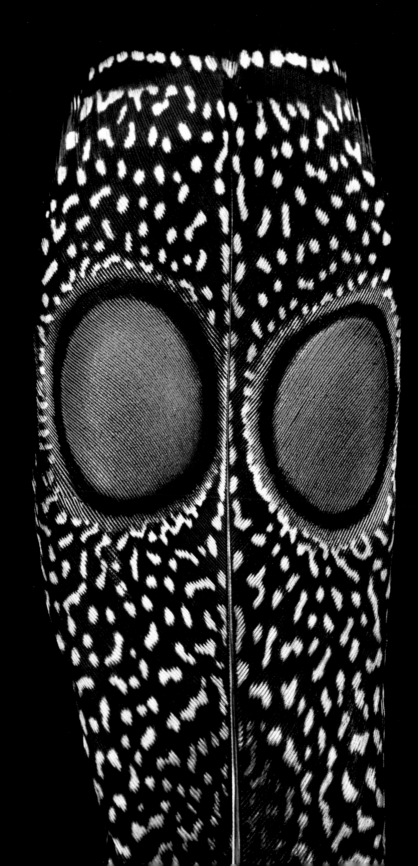

GOLDEN PHEASANT

—

CHINA

CHRYSOLOPHUS PICTUS

The male Golden Pheasant—also known as the Chinese Pheasant—
is an extravagant creature. Featuring reds and yellows, every section of
their plumage is a vibrant color. But despite the male bird's showy appear-
ance, it is not as visible as one might assume in its dark, coniferous-
forested habitat in Central China. The layered distribution of the
bird's feathers obscures the less colorful bases of the crest feathers.

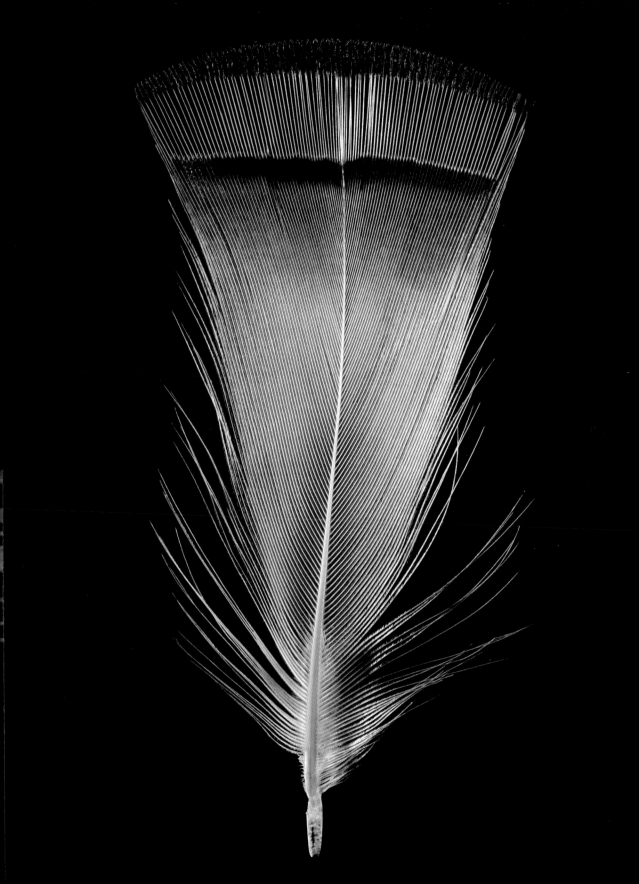

GOLDEN PHEASANT
[detail]

—

A detailed view of the Golden Pheasant's crest feathers overlaid over one another. Crest feathers such as these are ornamental. But though they serve no flight function, these feathers are crucial to attracting a mate. Males with vibrant colorations and well-preened feathers are the most attractive suitors. The layered distribution of the bird's feathers obscures the less colorful bases of the crest feathers.

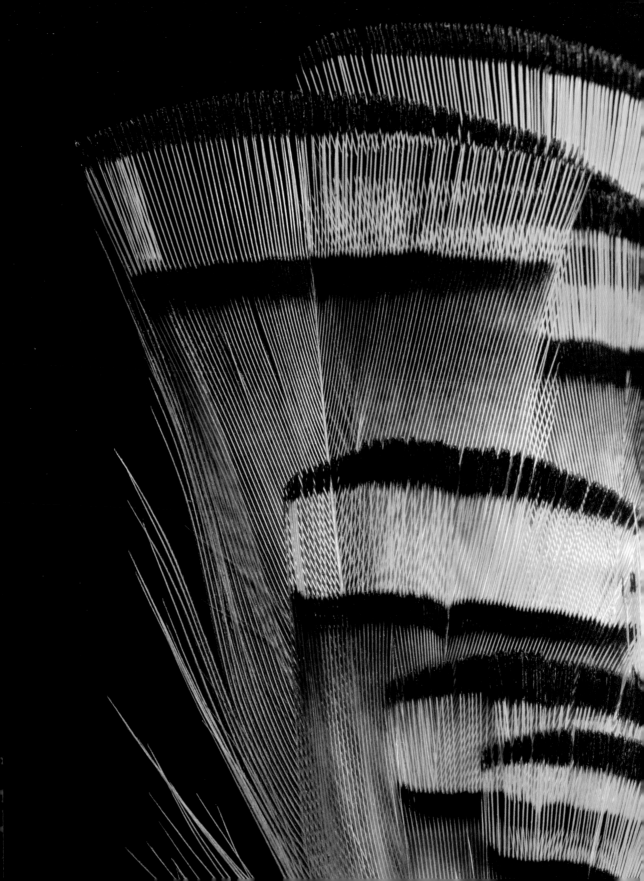

GOLDEN PHEASANT

[detail]

—

This detailed view of a contour feather from the top of the bird's head provides a closer look at the plumage that gives the Golden Pheasant its name. These ornamental feathers lack barbules, which means the barbs of the feathers can lay at any angle, giving the crest its explosive appearance.

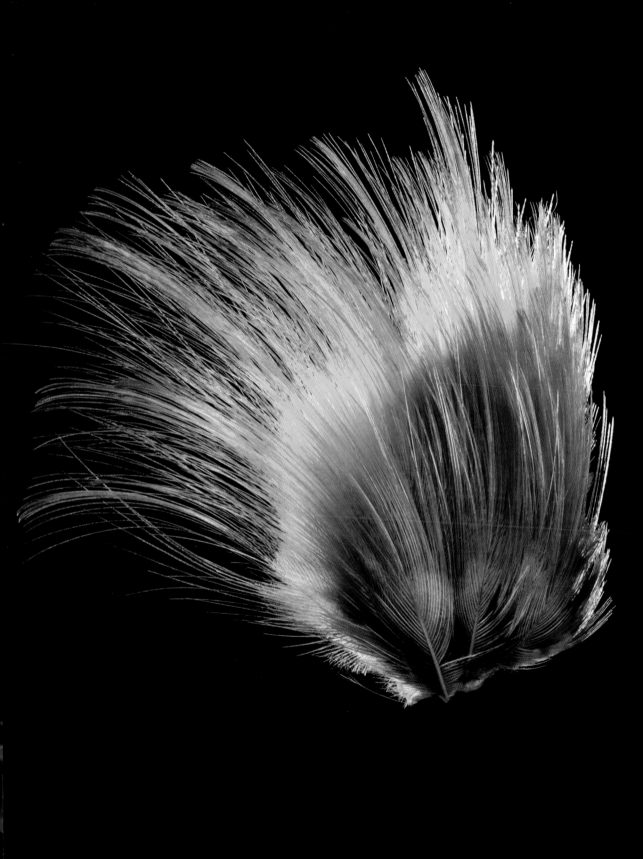

following spread:

FLAMINGO

—

AFRICA, SOUTHERN EUROPE, AND PARTS OF ASIA
PHOENICOPTERUS ROSEUS

The Greater Flamingo's signature pink coloring is the result of its diet: Flamingos consume massive amounts of animal and plant plankton very rich in beta carotene. A rich pink coat indicates the bird has a healthy diet, making it more attractive to potential mates.

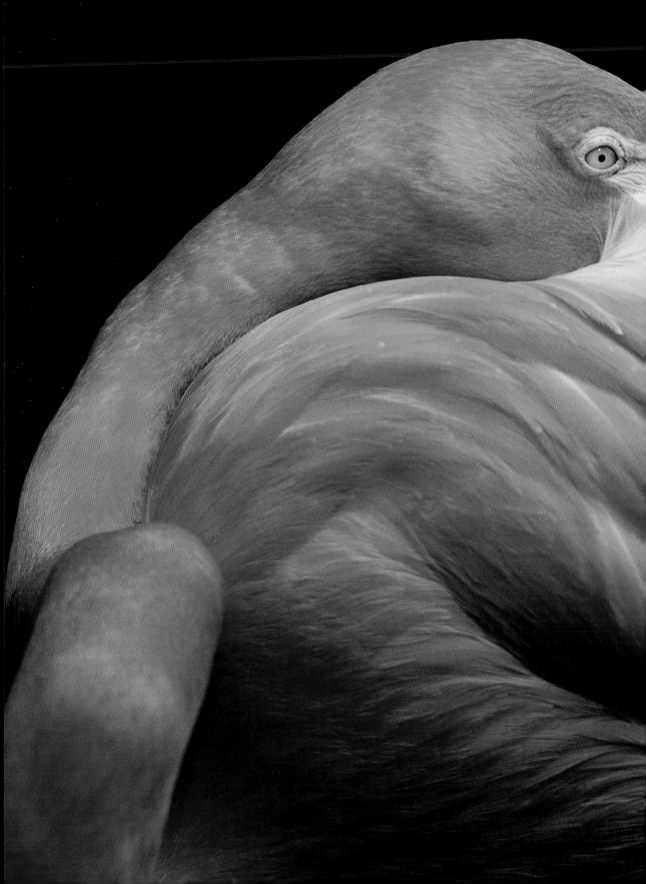

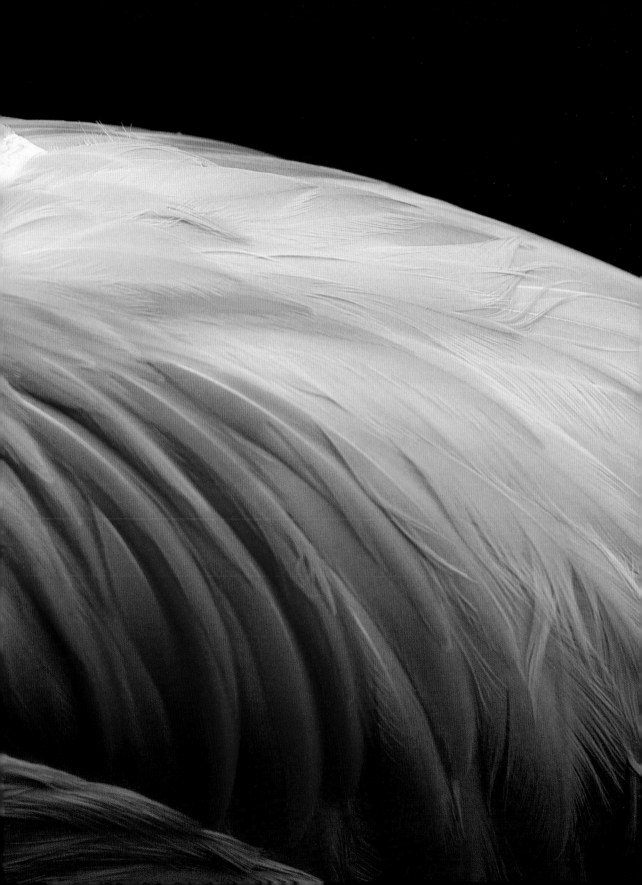

following spread:

PALM COCKATOO

—

NEW GUINEA / CAPE YORK, NEW SOUTH WALES
PROBOSCIGER ATERRIMUS

This member of the Cacatuidae family is one of the largest in the lineage, meriting the nickname the Goliath Cockatoo. The Palm Cockatoo is known for its ability to pronounce complex sounds, as well as interesting territorial displays in which males use seed pods to drum against hollow trees.

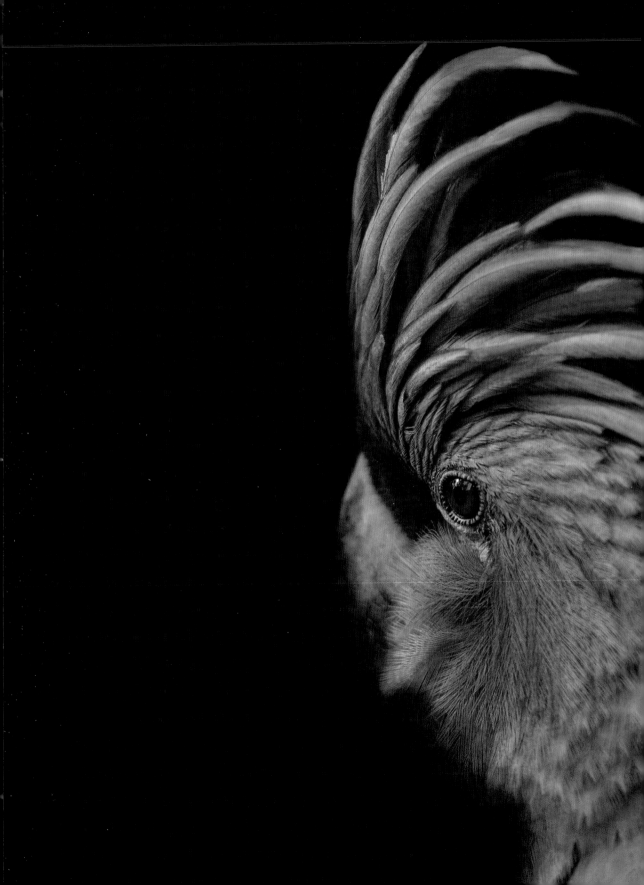

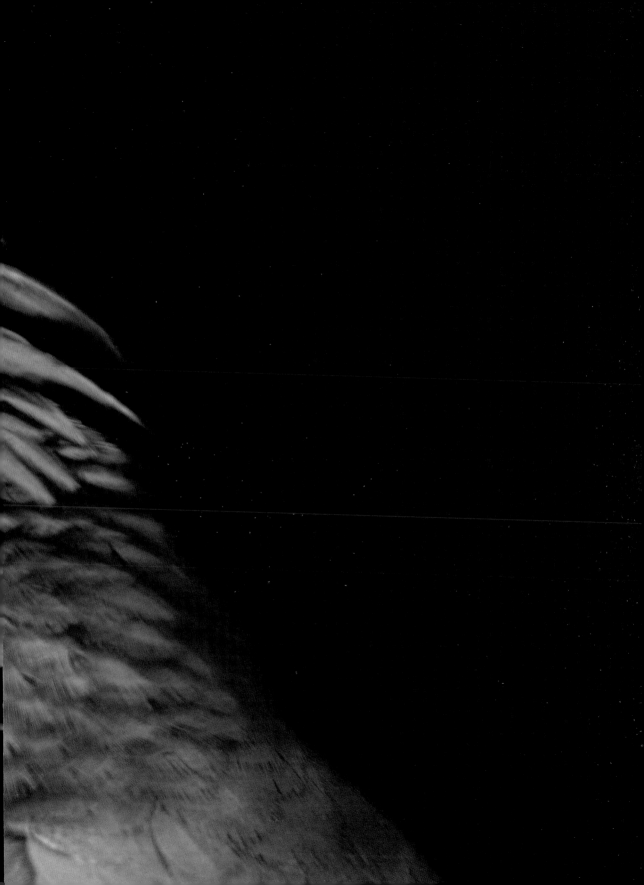

GREATER PAINTED-SNIPE

—

AFRICA, INDIA, AND SOUTHEAST ASIA

ROSTRATULA BENGHALENSIS

Greater Painted-Snipe display reverse sexual dimorphism, in which the female is the larger and more colorful of the mating pair. Female birds have rich brown feathers and a black band across their breast, while the male birds are paler. A wading bird, the Snipe walks through the shallows of reed beds in search of insects, crustaceans, mollusks, and seeds.

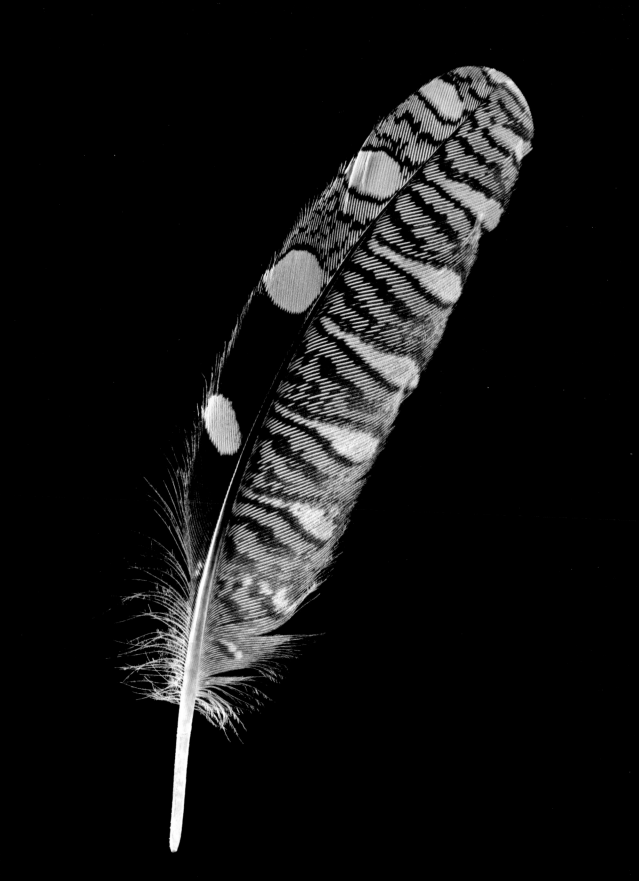

VICTORIA CROWN PIGEON

NEW GUINEA
GOURA VICTORIA

A member of a small genus of ground-dwelling pigeons from the Columbidae family, Victoria Crown Pigeons are known for their loud hooting call, sometimes accompanied by a clapping sound as their oddly shaped wings bat the air. Weighing in at more than seven pounds, they are considered the largest members of the Pigeon family.

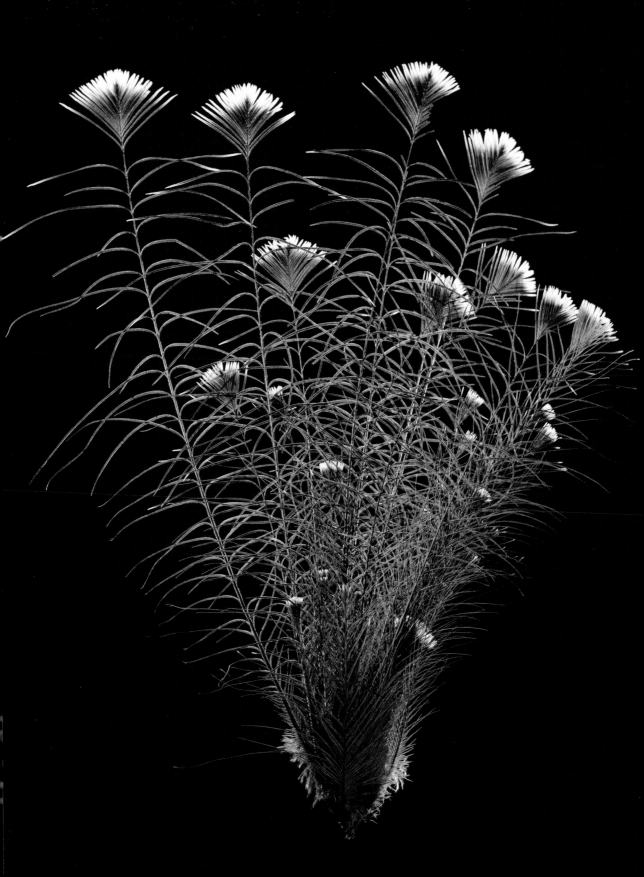

following spread:

WALLCREEPER

—

HIGH MOUNTAINS OF EURASIA
TICHODROMA MURARIA

The Wallcreeper lives in a hostile, mostly inhospitable environment of high-mountain cliff faces, some more than 16,000 feet high. Some insects and reptiles have flourished in this environment of few predators. The Wallcreeper evolved to take advantage of this habitat, developing extremely sharp claws and tough, broad feathers in their wings to push off against rock faces from their minuscule holds, bounding along the cliffs in short, powerful bursts.

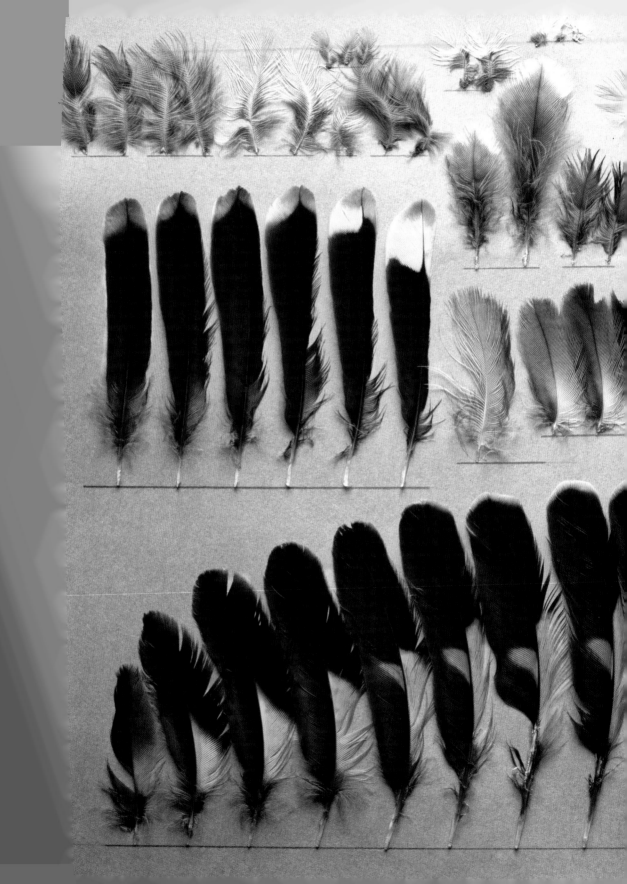

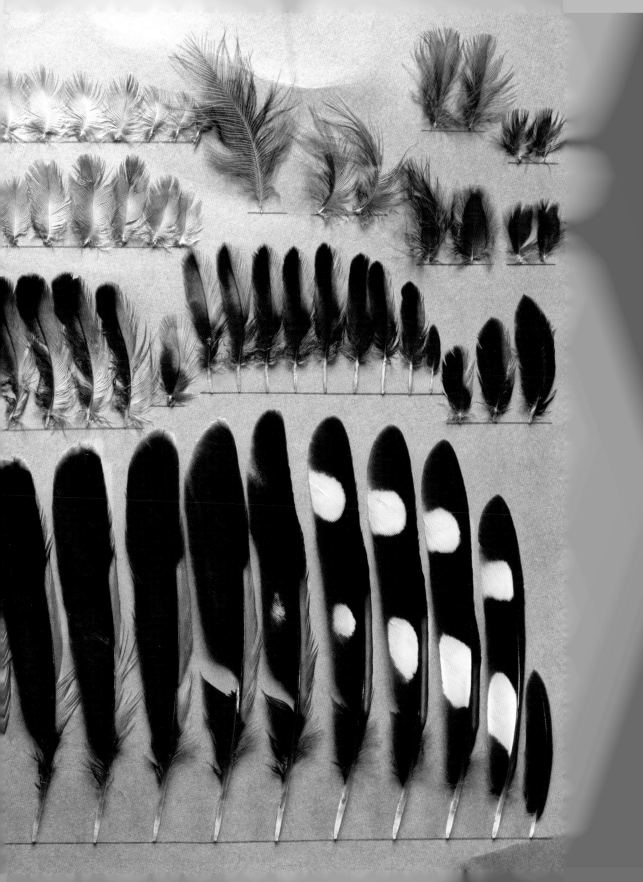

following spread:

BOHEMIAN WAXWING

—

UNITED STATES–CANADA BORDER

BOMBYCILLA GARRULUS

This exploded view shows all the feathers of the Bohemian Waxwing. With more than 3 million birds, this member of the Passeriformes order makes up one of the largest populations of passerine birds ranging throughout the Northern Hemisphere. The Waxwing is best known for getting drunk—they often eat the fermented rowan berries. Though their bodies are usually able to metabolize the alcohol, occasionally they do get fatally intoxicated.

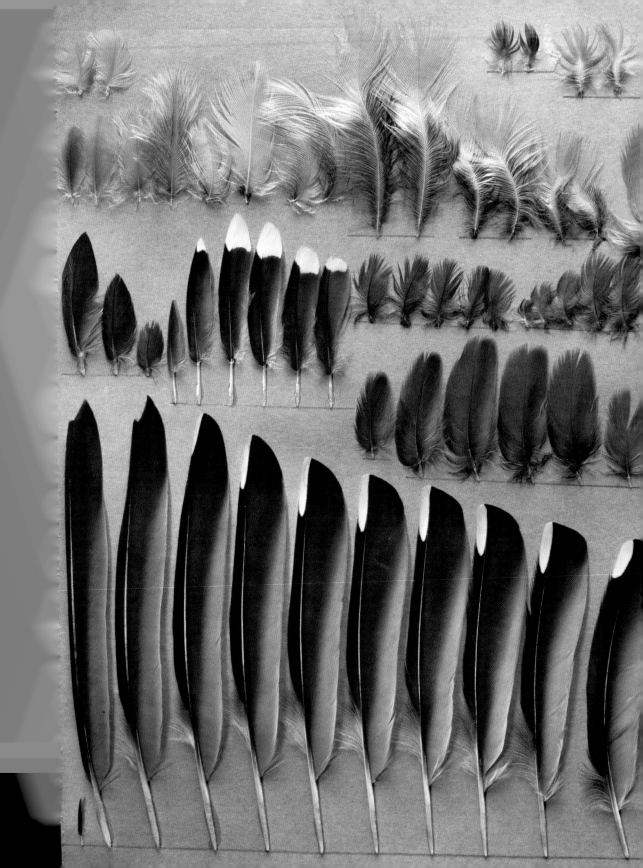

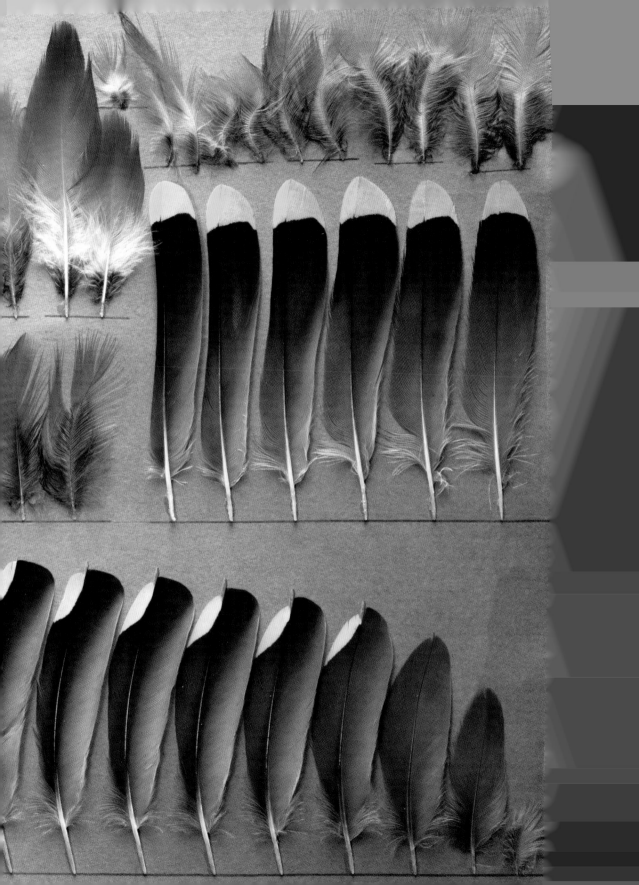

GLOSSARY

—

CALAMUS: the section of the feather shaft closest to a bird's body feathers

CONTOUR: outermost feathers that display color and provide shape

COVERT: feathers that cover other feathers and allow air to flow over the bird's wings and tail

CREST: prominent semiplume feathers on the top of a bird's head

DISTAL: end of feather farthest from bird's body

DOWN: fine feathers that provide warmth. Found underneath exterior feathers.

FLIGHT: wing and tail feathers that generate thrust and lift, allowing bird to fly

LEADING EDGE: edge of flight feather that faces forward during flight

MORPH: an adult bird that has distinctly different plumage than the standard colors for its species

OCELLI: the circular, eye-like patterns on a peacock feather

PRIMARY: the largest and strongest of the flight feathers

RACHIS: the distal end of a feather's shaft

SECONDARY: located between the bird's body and primary feathers, these feathers provide lift in both soaring and flapping flight

SEMIPLUME: feathers that provide an added layer of warmth and maintain the streamlined shape of the bird

SEXUAL DIMORPHISM: phenotypic differentiation between males and females of the same species

SPECULUM: a distinctly colored patch on the inside of a bird's wings

STRUCTURAL COLORATION: microscopically structured surfaces that interfere with visible light, often producing iridescent color

TRAILING EDGE: edge of flight feather that faces backward during flight

WING SLOTS: spaces at the end of the wings, between the primary feathers, which help the bird reduce drag during flight and provide lift

BIBLIOGRAPHY

African Wildlife Foundation. "Ostrich (*Struthio camelus*)." http://www.awf.org/wildlife-conservation/ostrich.

Arnold, Keith A. "The Red-Crowned Parrot (*Amazona viridigenalis*)." The Texas Breeding Bird Atlas. http://txtbba.tamu.edu/species-accounts/red-crowned-parrot.

Australian Department of the Environment Species Profile and Threats Database. "Southern Cassowary (*Casuarius casuarius johnsonii*)." http://www.environment.gov.au/cgi-bin/sprat/public/publicspecies.pl?taxon_id=25986.

———. "Southern Giant-Petrel (*Macronectes giganteus*)." http://www.environment.gov.au/cgi-bin/sprat/public/publicspecies.pl?taxon_id=1060.

Avian Web. "Palm Cockatoos Cockatoos aka Black Palm Cockatoos (*Probosciger aterrimus*)." http://beautyofbirds.com/palmcockatoos.html.

———. "Quaker (Monk) Parrot aka Grey-breasted Parakeet (*Myiopsitta monachus*)." http://www.beautyofbirds.com/quakerinfo.html.

———. "Red-billed Blue Magpies (*Urocissa erythrorhyncha*)." http://beautyofbirds.com/redbilledbluemagpies.html.

———. "Silver Pheasant (*Lophura nycthemera*)." http://beautyofbirds.com/silverpheasants.html.

BirdLife International. "Southern Giant Petrel (*Macronectes giganteus*)." http://www.iucnredlist.org/details/22697852/0.

BirdLife International: The IUCN Red List of Threatened Species. "Green-backed Trogon (*Trogon viridis*)." http://www.iucnredlist.org/details/22736238.

Bouglouan, Nicole. "Red-Crested Turaco (*Tauraco erythrolophus*)." Oiseaux Birds. http://www.oiseaux-birds.com/card-red-crested-turaco.html.

———. "Superb Starling (*Lamprotornis superbus*)." Oiseaux Birds. http://www.oiseaux-birds.com/card-superb-starling.html.

Brush, T., et al. "Amazona Viridigenalis." BirdLife International: The IUCN Red List of Threatened Species. http://www.iucnredlist.org/details/22686259/0.

Butchart, S., et al. "Wallcreeper (*Tichodroma muraria*)." BirdLife International. http://www.birdlife.org/datazone/species/factsheet/22711234.

Capper, D., et al. "Little Bustard (*Tetrax tetrax*)." BirdLife International. http://www.birdlife.org/datazone/speciesfactsheet.php?id=2759.

Carsten, Peter. "Ostrich (*Struthio camelus*)." National Geographic. http://animals.national geographic.com/animals/birds/ostrich.

The Cornell Lab of Ornithology. "Bohemian Waxwing (*Bombycilla garrulus*)." http://www.allaboutbirds.org/guide/Bohemian_Waxwing/lifehistory.

————. "Feather Structure." http://www.birds.cornell.edu/AllAboutBirds/studying/feathers/feathers.

————. "Fork-tailed Woodnymph (*Thalurania furcata*)." http://neotropical.birds.cornell.edu/portal/species/overview?p_p_spp=247451.

————. "Green-backed Trogon (*Trogon viridis*)." http://neotropical.birds.cornell.edu/portal/species/overview?p_p_spp=281976.

————. "Northern Flicker (*Colaptes auratus*)." http://www.allaboutbirds.org/guide/northern_flicker.

————. "Snow Goose (*Chen caerulescens*)." http://www.allaboutbirds.org/guide/Snow_Goose.

————. "Wilson's Bird-Of-Paradise: A Full Spectrum." http://www.birdsofparadiseproject.org/content.php?page=73.

Daniels, Dick. "Starlings of Africa and Their Allies." Birds of the World. http://carolinabirds.org/HTML/AF_Starling.htm.

Ducks Unlimited. "Mallard (*Anas platyrhynchos*)." http://www.ducks.org/hunting/waterfowl-id/mallard.

Dudley, Ron. "The Alula (Bastard Wing) of a Kestrel in Flight." Feathered Photography. http://www.featheredphotography.com/blog/2013/03/23/the-alula-bastard-wing-of-a-kestrel-in-flight.

Ekstrom, J., et al. "Broad-Billed Sandpiper (*Calidris falcinellus*)." BirdLife International. http://www.birdlife.org/datazone/speciesfactsheet.php?id=3061.

————. "Northern Fulmar (*Fulmarus glacialis*)." BirdLife International. http://www.birdlife.org/datazone/speciesfactsheet.php?id=3872.

————. "Sunda Minivet (*Pericrocotus miniatus*)." BirdLife International. http://www.birdlife.org/datazone/speciesfactsheet.php?id=5979.

Johnson, Sibylle. "Blood Pheasants (*Ithaginis cruentus*)." Avian Web. http://beautyofbirds.com/bloodpheasants.html.

————. "Blue and Gold Macaws aka Blue & Yellow Macaws (*Ara ararauna*)." Avian Web. http://www.beautyofbirds.com/blueandgoldmacaw.html.

————. "Blue-fronted Amazon Parrot or Turquoise-fronted Amazon (*Amazona aestiva*)." Avian Web. http://www.beautyofbirds.com/bluefrontedamazon.html.

———. "Golden-Headed Quetzals (*Pharomachrus auriceps*)." Avian Web. http://www.beautyofbirds.com/goldenheadedquetzals.html.

———. "White-Capped Parrots (*Pionus senilis*)." Avian Web. http://www.beautyofbirds.com/whitecappedpionus.html.

Kaufman, Kenn. "Northern Fulmar (*Fulmarus glacialis*)." *Audubon Guide to North American Birds*. http://www.audubon.org/field-guide/bird/northern-fulmar.

———. "Northern Flicker (*Colaptes auratus*)." *Audubon Guide to North American Birds*. http://www.audubon.org/field-guide/bird/northern-flicker.

Lafeber. "Budgie (Parakeet; *Melopsittacus undulatus*)." http://lafeber.com/pet-birds/species/budgie-parakeet.

Mayntz, Melissa. "Eurasian Jay (*Garrulus glandarius*)." About.com. http://birding.about.com/od/Jays-Orioles/p/Eurasian-Jay.htm.

———. "Lilac Breasted Roller (*Coracias caudatus*)." About.com. http://birding.about.com/od/Dippers-Kingfishers/p/Lilac-Breasted-Roller.htm.

National Geographic. "Mallard Duck (*Anas platyrhynchos*)." http://animals.nationalgeographic.com/animals/birds/mallard-duck.

———. "Peacock (*Pavo, Afropavo*)." http://animals.nationalgeographic.com/animals/birds/peacock.

One Kind. "Ostrich (*Struthio camelus*)." http://www.onekind.org/be_inspired/animals_a_z/ostrich.

Powys, Vicki, et al. "A Little Flute Music: Mimicry, Memory, and Narrativity." *Environmental Humanities* 3, 2013. http://environmentalhumanities.org/arch/vol3/3.3.pdf.

Schulenberg, T. S. "Golden-headed Quetzal (*Pharomachrus auriceps*)." Cornell Lab of Ornithology. http://neotropical.birds.cornell.edu/portal/species/overview?p_p_spp=284696.

Scott, S. David. *Bird Feathers: A Guide to North American Species*. Mechanicsburg, PA: Stackpole Books, 2010.

SeaWorld Parks & Entertainment. "Golden-Breasted Starling (*Cosmopsarus regius*)." http://seaworld.org/animal-info/animal-bytes/birds/golden-breasted-starling/.

———. "Red-Crested Turaco (*Tauraco erythrolophus*)." http://seaworld.org/animal-info/animal-bytes/birds/red-crested-turaco.

St. John, James. "Confuciusornis sanctus." The Ohio State University Newark. http://www2.newark.ohio-state.edu/facultystaff/personal/jstjohn/Documents/Cool-fossils/Confuciusornis-sanctus.htm.

Switch Zoo. "Scarlet Macaw (*Ara macao*)." http://switchzoo.com/profiles/scarletmacaw.htm.

Taylor, Hollis. "Lyrebirds Mimicking Chainsaws: Fact or Lie?" The Conversation. http://theconversation.com/lyrebirds-mimicking-chainsaws-fact-or-lie-22529.

Wildscreen Arkive. "Broad-Billed Sandpiper (*Limicola falcinellus*)." http://www.arkive.org/broad-billed-sandpiper/limicola-falcinellus.

————. "Common Swift (*Apus apus*)." http://www.arkive.org/common-swift/apus-apus.

————. "Great Argus (*Argusianus argus*)." http://www.arkive.org/great-argus/argusianus-argus.

————. "Greater Painted-Snipe (*Rostratula benghalensis*)." http://www.arkive.org/greater-painted-snipe/rostratula-benghalensis.

————. "Indian Roller (*Coracias benghalensis*)." http://www.arkive.org/indian-roller/coracias-benghalensis/.

————. "King Bird-of-Paradise (*Cicinnurus regius*)." http://www.arkive.org/king-bird-of-paradise/cicinnurus-regius.

————. "Little Bustard (*Tetrax tetrax*)." http://www.arkive.org/little-bustard/tetrax-tetrax/.

————. "Scarlet Macaw (*Ara macao*)." http://www.arkive.org/scarlet-macaw/ara-macao/.

————. "Snow Goose (*Chen caerulescens*)." http://www.arkive.org/snow-goose/chen-caerulescens.

————. "Southern Cassowary (*Casuarius casuarius*)." http://www.arkive.org/southern-cassowary/casuarius-casuarius.

————. "Spotted Eagle-Owl (*Bubo africanus*)." http://www.arkive.org/spotted-eagle-owl/bubo-africanus.

————. "Victoria Crowned-pigeon (*Goura victoria*)." http://www.arkive.org/victoria-crowned-pigeon/goura-victoria.

————. "Wilson's Bird-of-Paradise (*Cicinnurus respublica*)." http://www.arkive.org/wilsons-bird-of-paradise/cicinnurus-respublica/.

Wilson, Angus. "Broad-Billed Sandpiper (*Limicola falcinellus*)." The New York State Avian Records Committee. https://nybirds.org/NYSARC/RareGallery/BbillSP.htm.

Winkler, Sarah. "How Can Owls Fly Silently?" How Stuff Works. http://animals.howstuffworks.com/birds/owl-fly-silently1.htm.

Woburn Safari Park. "African Spotted Eagle Owl (*Bubo africanus*)." http://www.woburnsafari.co.uk/discover/meet-the-animals/birds/african-spotted-eagle-owl.

Xeno-Canto Foundation. "King Bird-of-paradise (*Cicinnurus regius*)." http://www.xeno-canto.org/species/Cicinnurus-regius.